Artist: Francine Auger

Emily Carr, 1871-1945.

Kate Braid

Kate Braid holds a Master of Arts degree in Communication from Simon Fraser University and a Master of Fine Arts degree in Creative Writing from the University of British Columbia. She also holds an interprovincial trades qualification certificate in Construction Carpentry. She worked as a labourer, apprentice, and journey carpenter from 1977 – 1991.

In 1999, Kate Braid's third book of poems, *Inward to the Bones: Georgia O'Keefe's Journey with Emily Carr*, won the VanCity Book Prize for the best book on women's issues. Her 1995 book *To This Cedar Fountain* was nominated for the Dorothy Livesay Poetry Prize, and her first poetry title, *Covering Rough Ground*, won the 1991 Pat Lowther Memorial Award for best book of poetry by a Canadian woman. She has prepared two one-hour documentaries for CBC Radio, *Ideas*. Her poems, essays, and nonfiction writing have been published in numerous journals and anthologies. Her first nonfiction book, *Red Bait! Struggles of a Mine Mill Local*, was published in 1998.

Kate Braid has worked extensively as a teacher, consultant, and speaker. Since 1998 she has been employed as a Creative Writing instructor at Malaspina University-College in Nanaimo, B.C.

Editorial correspondence:
Rhonda Bailey, Editorial Director
XYZ Publishing
P.O. Box 250
Lantzville BC
V0R 2H0
E-mail: xyzed@telus.net

Emily Carr

Canadian Cataloguing in Publication Data

Braid, Kate, 1947-

Emily Carr : rebel artist

(The Quest Library ; 6)
Includes bibliographical references and index.

ISBN 0-9683601-6-5

1. Carr, Emily, 1871-1945. 2. Painters – Canada – Biography.
3. Authors, Canadian (English) – Biography. I. Title. II. Series.

ND249.C3B72 2000 759.11 C00-940654-9

Legal Deposit: Second quarter 2000
National Library of Canada
Bibliothèque nationale du Québec

XYZ Publishing acknowledges the support of The Quest Library project by the Canadian Studies Program and the Book Publishing Industry Development Program (BPIDP) of the Department of Canadian Heritage. The opinions expressed do not necessarily reflect the views of the Government of Canada.

The publishers further acknowledge the financial support our publishing program receives from The Canada Council for the Arts, the ministère de la Culture et des Communications du Québec, and the Société de développement des entreprises culturelles.

Chronology and Index: Lynne Bowen
Layout: Édiscript enr.
Cover design: Zirval Design
Cover illustration: Francine Auger

Printed and bound in Canada

XYZ Publishing
1781 Saint Hubert Street
Montreal, Quebec H2L 3Z1
Tel: (514) 525-2170
Fax: (514) 525-7537
E-mail: xyzed@mlink.net

Distributed by: General Distribution Services
325 Humber College Boulevard
Toronto, Ontario M9W 7C3
Tel: (416) 213-1919
Fax: (416) 213-1917
E-mail: customer.service@emailgw.genpub.com

CARR

Emily

REBEL ARTIST

XYZ
Publishing

There are hundreds of ways
to kneel and kiss the ground.
– Rumi

She is the voice that says,
"This way, this way."
– Clarissa Pinkola Estes

This book is for the Wild Woman

Contents

Preface

Language has changed since Emily Carr's time. For example, in Emily's day First Nations people were called "Indians," and their own names and place names were arbitrarily anglicized. The large set of islands north of Vancouver Island that are today called Haida Gwaii were then called the "Queen Charlotte Islands"; the Kwakwaka'wakw people were referred to as "Kwakiutl"; the Nuu-chah-nulth as "Nootka"; and so on. For gender, the pronoun "he" was used as a neutral word to refer to both men and women.

When quoting her, I repeat Emily's own vocabulary, which will at times sound old-fashioned to modern ears. In the rest of the text, I have tried to remain true to current spelling and names. However, in the present context of rapidly shifting linguistics, there may be inadvertent errors; if so, I would appreciate being informed of them in order to make corrections to future editions.

All of the quotations in this work are taken from Emily Carr's books. However, in her work she frequently distorts (or misremembers) facts, especially her age. So, for example, when her mother died she says

she was twelve when she was actually fourteen. When she went to San Francisco she says she was "almost sixteen" when she was almost nineteen, and so on.

She also changes people's names so that, for example, her suitor, Mayo Paddon, becomes Martyn. I have here used her actual age and the real names of people connected with her, as confirmed by her biographers.

Emily Carr was an excellent and prolific writer about her own life. I have relied heavily on her journals and books for details in this manuscript, particularly in Chapter 1, in order to keep as close as possible to Emily's experience of important events in her life.

Unless otherwise noted, all quotations are from Emily Carr's own writings as reprinted in *The Emily Carr Omnibus* (1993. Introduction by Doris Shadbolt). Sincere thanks to the publishers of *The Emily Carr Omnibus*: Douglas & McIntyre (Vancouver/Toronto) and the University of Washington Press (Seattle). Also thanks to Stoddart Publishing for their confirmation that Emily Carr's work is in the public domain.

Thanks for their assistance to the folk at B.C. Archives and the Vancouver Art Gallery; to Jan Ross at Emily Carr House in Victoria, B.C.; Martha Black at the Royal British Columbia Museum; Miriam Clavir, Marilyn Dumont, and Jada Pape. A warm thank you to Rhonda Bailey and Lynne Bowen.

I am particularly grateful for the excellent and detailed biographies of Emily Carr by Maria Tippett and Paula Blanchard, which I have used as my sources for factual material. Thank you also to Maria Tippett for checking the final manuscript for accuracy.

Mostly thanks, once again, to Emily.

1

Meeting D'Sonoqua

The Indian people and their art touched me
deeply.

— Emily Carr, *Growing Pains*

I t had rained all day: a grey, ceaseless downpour
under heavy skies. All day she had waited for the
Indian agent who promised to take her to the remote
village where local people told her she would find
totem poles. She had been travelling for days – by
coastal freighter, fishboat, launch, or canoe – however
she could reach the next small village, the next pole.
She was going to sketch them before they all disap-
peared, as she feared, forever.

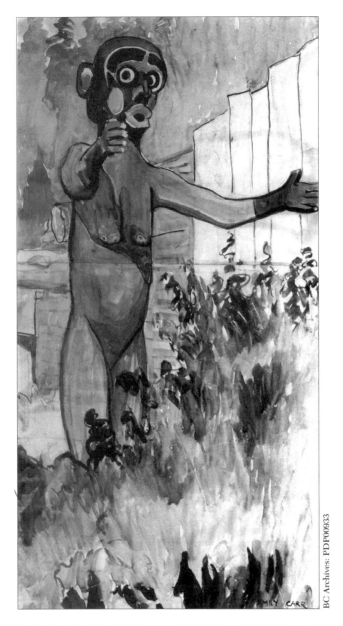

Emily Carr's painting of D'Sonoqua, wild woman of the woods. It was the first time Carr met this supernatural figure, towering above stinging nettles in the abandoned village of Gwa'yasdams in northern British Columbia.

And so she waited, in the mission or perhaps in some native cabin, while the Indian agent went about his business, took his time, almost forgetting about the lone white woman whose luggage consisted mostly of a sketch sack, a blanket roll, and a dog for company.

Finally, he was ready. The woman lifted her few belongings to her shoulders, called in a soft English accent to the young native girl who would accompany her on the site, and the three of them climbed into his open boat. When they arrived at the deserted village of Gwa'yasdams, it was dusk. The woman and child stood on shore and stared up at the frightening tall figures of totem poles, which leaned forward as if to touch the visitors.

"There is not a soul here. I will come back for you in two days," the Indian agent said, and left them alone. As his boat rounded the shoulder of the bay and disappeared, the little girl burst into tears. "I'm 'fraid," she said.

The woman led the way up a narrow path over-grown with stinging nettles. It was dark when they reached the empty mission house. As the door creaked open, they heard the scamper of rats. The woman tried to make them comfortable by building a fire, perhaps to cook some food, but the firewood was wet and she couldn't make the stove work. She had no candles, so they ate her canned food in darkness, then laid their blankets on the floor and slept.

The next morning the air was a curtain of damp-ness. When the woman followed the plank walk, she had to cut through stinging nettles that reached over her head. Her thick clothes and long skirt and

stockings protected her a little, but nettles bit at her face and hands. Slime from thick yellow slugs coated the wet wood under her feet. Suddenly, with a cry, she fell. When Emily Carr looked up, an immense wooden figure loomed over her.

The creature had been carved from a huge red cedar tree. She was so tall, the nettles barely reached her knees. Her long arms stretched wide as if about to grab someone. But it was her face that seized Emily's attention.

Her eyes were two dark sockets outlined in dazzling white under fierce, black eyebrows. Emily felt as if at any minute the cry of the tree's heart might fly out from the protruding lips that framed her open mouth. At the ends of two black hands, the figure's fingertips were painted ghostly white. Round ears jutted from her head as if to miss nothing, and rain and mist put a slick gloss on the red of her body, arms, and thighs.

Emily pushed through to the bluff so she could look back and see all of the creature. She sketched, and watched, for a long, long time – until a thick mist moved in off the sea and the figure disappeared.

"Who is that image?" she asked the little native girl. She could see the child knew what she was speaking of, but the girl said, "Which image?"

"The terrible one, out there on the bluff."

"I dunno," the girl lied.

All that night, as the child slept, Emily sat at the open window of the mission house and listened to the foreign sounds outside their thin shelter: the cries of an abandoned dog, the crash of breakers, and the groaning, living sounds of huge trees around her. She was

afraid, but she was also deeply moved. She felt as if something had called her, as if she were on a quest.[1]

∽

Five years earlier, on a trip to Alaska in 1907 with her sister, Emily Carr had been deeply impressed by the totem poles she saw. She loved their monumental size and majesty. She was already a serious artist who had studied in San Francisco and London, and now, when she did some sketches on the spot, an American artist who spent every summer in Sitka told her he wished he had done them because they had "the true Indian flavour." His praise got her thinking.

In trying to convert the First Nations peoples to Christianity, missionaries, with the co-operation of national governments, had virtually condemned traditional native culture. They declared all symbols and tools of traditional native life – masks, rattles, ceremonial regalia, and the totem poles, as well as important festivals such as the potlatch – "pagan." The native population was already plummeting, decimated by diseases introduced by contact with white people – smallpox, tuberculosis, and alcoholism among them. Many of the native people who survived were now moving to larger centres for all or part of the year so they could get jobs at white people's canneries and mission stations. As the villages emptied, their totem poles were being cut down, burned, or sold to museums and to

1. Paula Blanchard, *The Life of Emily Carr*, Vancouver/Toronto: Douglas & McIntyre & Seattle: The University of Washington Press, 1998, p. 129.

rich tourists as "souvenirs." Others were simply rotting naturally.

Emily Carr had probably never seen standing totem poles in their natural setting until she went to Alaska. On Vancouver Island she was familiar with the Coast Salish and Nootka (now Nuu-chah–nulth) people, but they were not carvers in the same tradition as the northern Tlingit whose work she now so admired. She certainly didn't understand the meaning of these monumental carvings in the same way native peoples did. She didn't understand, for example, that their rotting in place was considered a natural part of their cycle. As a non-native, deeply Christian woman born into the perspectives of her time, she couldn't appreciate the full importance of the standing poles in affirming lineage, rights, and privileges within the communities that raised them. But she was one of the very first Europeans to see past the deep racial bias of her time to admire the skill of native carvers and the power that shone out of their work. She knew the poles were an important part of cultural identity here in the northwest – and she knew they were rapidly disappearing.

As the ship carried her back to Victoria, Emily made a decision: she would document the totem poles of British Columbia. She would make as accurate a record as she could, of as many poles as she could find in the entire vastness of the province. It would be her way of preserving them, at least on canvas; it would be her mission.

And, true to her promise, over the next twenty years she made eight trips to the northwest and Interior of B.C., to the northern coast of Vancouver

Island, and to the Queen Charlotte Islands – now known as Haida Gwaii – seeking totem poles. Later she would come to paint other things, including the forest itself, but for now, her focus was all on the totem poles in northern native villages.

For a single white woman in the remotest parts of B.C. in the early 1900s, alone except for her dog and sometimes a native companion or guide, it was an extraordinary odyssey. She rode on trains, steamers, wagons, fishing boats, and canoes. She stayed in tents, roadmakers' tool sheds, missions, and in native people's homes. Sometimes she asked a boat owner to leave her alone in a deserted village for days at a time, all so she could fulfil her promise to herself to preserve the power and beauty of the totem pole.

The poles appealed to Emily's love of spirit, to her love of the truth – the art – revealed by going to the heart of things. She appreciated how, without lies or hypocrisy, the First Nations carver caught what seemed to her the inner intensity of his subject, by going even to the point of distortion so the spirit expressed in the carving gained strength and power.

Sketching the poles, spending long periods of time alone in the forest, taught Emily Carr many things, but always, that fierce female totem pole figure with its deep black eyes and shouting mouth seemed especially to talk to her.

∞

They met again, years later, in a small village where Emily had come to sketch totem poles. The traditional

large community houses of native villages were slowly falling down and being replaced by smaller buildings. On this day, Emily walked inside the frame of one old building in which the huge centre beam had fallen and rotted away. But one of the carved figures that had supported the beam still stood.

Emily knew instantly who it was by the figure's jutting ears, wide-open eyes, and calling mouth. Her carved body was dried and cracked by the sun. In some ways she was even more terrifying, for her two hands gripped the mouths of two upside-down human heads, and the sun cast deep hollows around the angles of her face.

When Emily asked her native guide, "Who is she?" he was slow to answer, as if he resented this intrusion of a white woman into matters entirely Indian. Finally he answered, "D'Sonoqua." He pronounced it in a way Emily's tongue could not follow.

"Who is D'Sonoqua?"

"She is the wild woman of the woods."

"What does she do?"

"She steals children."

"To eat them?"

"No, she carries them to her caves." And he pointed across the water to a purple scar on the mountain's side. "When she cries, 'oo-oo-oo-oeo'," he said, "Indian mothers are too frightened to move. They stand like trees, and the children go with D'Sonoqua."

"Then she is bad?"

"Sometimes bad...sometimes good," and he walked away, as if he had already said too much.

As Emily understood her, D'Sonoqua was a super-

natural being. Again she stared for a long time, sketching, watching. Finally, as she turned away, two things caught her eye. One was a small bird building its nest in D'Sonoqua's round mouth. The other was the soft shape of a tabby cat, sleeping unafraid at D'Sonoqua's feet.

Later, as Emily waited for the little boat that would come (she hoped) to pick her up and take her to the next small village, she mused, "I do not believe in supernatural beings. Still – who understands the mysteries behind the forest? What would one do if one did meet a supernatural being?" And then, "Half of me wished that I could meet her, and half of me hoped I would not."

Many years later she *would* meet D'Sonoqua, the wild woman of the woods, one last time.

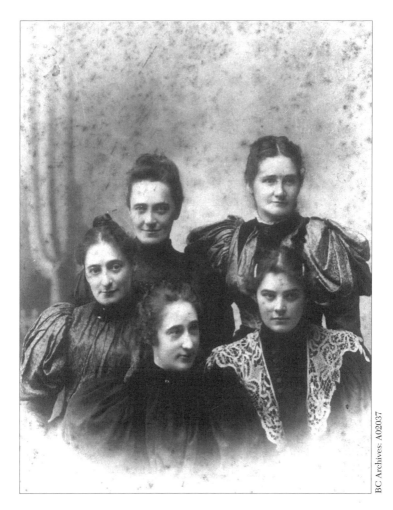

Emily Carr (lower right) about age sixteen, with her sisters
(from centre front, clockwise) Alice, Lizzie, Edith, and Clara.
Emily always felt like the black sheep of her family.

2

Growing up Small

Our family had to whiz around Father like a
top round its peg.
 – Emily Carr, *The Book of Small*

E mily Carr was born the eighth child in a family of
nine. The three older boys all died, so there was a
gap of almost twenty years between what she later called
"the big family," of the two oldest girls, Edith and Clara,
and the "little family" that consisted of Lizzie, Alice,
Emily, and the youngest child, Dick. Dick was always
unhealthy and eventually he, too, would die young.

Richard Carr, their father, was born in England.
When he made a small fortune as a gold prospector

and merchant in California, he wanted to retire. But having tasted the excitement of the new world, he didn't want to live in England again, even though he considered England and all things English to be the finest on earth. His solution, in 1863, was to move with his wife, Emily, and two daughters, Edith and Clara, to Victoria. In what was then still the colony of Vancouver Island, he could continue to live as a British citizen.[2]

Within a year he set up a thriving business that sold wholesale groceries and liquors on Wharf Street. Nearby, within easy walking distance, he built a splendid new house in fashionable James Bay bordering Beacon Hill Park – a beautiful piece of wild land that overlooked the Strait of Juan de Fuca.

∽

Today, the house at 207 Government Street has been largely restored to how it was in Emily's day, a handsome yellow two-storey clapboard structure with gracefully arched front windows and a pleasant front porch. For a house of its time it is richly trimmed. From the eaves hang what carpenters call "acorn drops" like long, elegant Christmas balls. From its roof reach up "finials," like Christmas balls reversed so the effect is the architectural equivalent of a woman wearing her best jewels.

The area in front of the house used to be a large garden that Richard Carr planted to look as much as

2. In 1871, the year of Emily Carr's birth, B.C. became the seventh province to join Confederation.

possible like England. Today, it is a broad drive and parking area. Modern guests are asked to enter the house by the back entrance into what was once the kitchen, but in Emily's day, a visitor walked up the seven front steps and across the porch to a wide front door whose glass panels looked into the front hallway.

The hallway is not large but is designed to be impressive. Its floor is painted oilcloth, and the walls are wallpaper painted to look like marble. As you stand in the hallway, to your right is the dining room where Emily would later hold art classes for Victoria's children, and to your left, the parlour where Mrs. Carr and the local ladies sat properly straight-backed for afternoon tea. Throughout the house, tall windows framed by heavy draperies reach almost to the high ceilings. There are lavish mouldings, high baseboards, and heavy mahogany-and-horsehair furniture. Although the family would later be one of the first in Victoria to have electricity installed, above your head in the hallway hangs the original pink kerosene light fixture, suspended by Mr. Carr's tradesmen from a plaster rosette.

Now go up the stairs. At the top, to your right, is the indoor bathroom installed for Mrs. Carr when she grew sick. On your left are the children's bedrooms. Up another four stairs and to the right is Mrs. Carr's bedroom, the one where Emily, her youngest daughter and namesake, was born.

Emily, being "contrary from the start," was in no hurry. When her mother went into labour it was a cold, stormy day in December. Outside, an icy wind blew, and coal was no doubt steadily poured into the bedroom's small fireplace. All day the family waited for this

stubborn child to come. Finally, at 3:00 a.m. Mr. Carr hurried into his heavy coat and out into the storm to find Nurse Randal, the midwife. The date was December 13, 1871.

∞

Emily's mother was small, quiet and a little shy with her own children. She had grey eyes like Emily's, dark hair, and cheeks that Emily always remembered as pink. This was probably the effect of fever, for she was frequently ill and spent days resting in her darkened room, often struggling for breath.

Emily's father, Richard, was fierce and cranky, and as Victorian men were expected to do, he ruled his large family with a stern eye and an iron temper. When he came home from his store at six o'clock, he strode through the house, frowning if any neighbourhood children or ladies dared still to be visiting. Then he went directly to tend his favourite plant, a huge grapevine that grew on one side of the house. He called the vine Isabella and sometimes Emily thought he doted more on the plant – pruning, pinching and petting it – than he ever did on the human beings inside.

From the time she could talk, Emily was her father's favourite. He always said she should have been the boy, and he insisted she be with him whenever he was home working in the garden. She passed him bulbs to plant or held the cloth strips he used to tie up Isabella. Every morning Emily walked most of the way into town with him, and every evening she met him to walk him home again.

∽

The family was very religious. There were daily prayers and Bible readings but the most important day of the week was Sunday. On that day, no one worked. By Saturday night the house was polished, Sunday's food was cooked, and Sunday's clean clothes pressed and hung out to be aired. All that remained was for the children to be scrubbed. After dinner the big washtub was set in the middle of the kitchen floor and – since there was no running hot water – every kettle and soup pot, including the family wash-boiler, was set to boil. When all the pots were steaming, oldest sister Edith (who the children nicknamed "Dede") donned her thick white apron, heated the towels, and fetched the brown windsor soap. Then Mrs. Carr presented each child in turn while Dede scrubbed.

The next morning at 7:00 a.m. precisely, their father woke the children with the announcement, "It's Sunday, children." But they could already tell that from the smell of Wright's coal-tar soap and the camphor in which he stored his very best Sunday clothes.

Sunday was stuffed full of church; there were morning prayers and evening Bible readings, morning Presbyterian service at their father's church and evening Reformed Episcopal service at their mother's, with Sunday school (taught by Dede) squeezed in between. At noon, dinner was a cold saddle of mutton roasted the day before in the big oven Richard Carr had brought with him from England – because everything English, he believed, was better than anything Canadian. After dinner, one child was picked to recite

the morning's sermon to see how much they remembered. Dede, Lizzie, and Alice always remembered the text. Emily remembered the jokes.

At the very end of the day, Emily struggled to stay awake while her father read a short chapter from *Sunday at Home* magazine. This was as good as it got because he believed that fairy stories were bad for children.

∽

At school her sisters were all good students, but Emily was often in trouble for not paying attention and for endlessly drawing faces on her fingernails, pinafores, and textbooks. She loved to draw.

One day she stared at the family's pet dog for a long time. Then she slit open a large brown paper bag, took a charred stick from the fireplace, and drew a dog. When she proudly showed it to her family, her older sister said, "Not bad."

Her father spread it over his newspaper, put on his spectacles and said, "Um!" and her mother said, "You are blackened with charred wood, wash!" Years later the drawing was found in her father's papers with his comment, "By Emily, aged eight."

Sketching and painting on porcelain or in watercolour were considered healthy for children and admirable accomplishments for genteel young ladies, and Emily's parents encouraged all their daughters to take drawing lessons from Miss Emily Wood, who came to the house each Monday with pictures for the children to copy. Emily soon won a prize for copying a boy with a rabbit.

The next time her father pruned the cherry tree, young Emily claimed three of the straightest sticks, tied them at one end, spread them at the other and drove two big nails in to hold her drawing board. When she put this little easel under her bedroom window, she felt like a real artist.

∽

It seemed that young Emily was always in trouble. Once when her mother was very ill, Emily and Alice were sent to stay with the neighbours, Mr. and Mrs. Crane. Emily and Mrs. Crane immediately locked horns because Mrs. Crane thought Emily was "naughty." Once, as Mrs. Crane was reading them a very dull story, Emily entertained herself by tying the fringe of an antimacassar into dozens of beautiful pigtails.

The next morning Mrs. Crane was furious. She said Satan must have made Emily do it and humiliated her by making her confess in front of the whole family and then undo every pigtail.

Another time when Emily was feeling ill and unhappy and homesick, Mrs. Crane dosed her with castor oil. The next day while Emily and Helen, the youngest Crane, were playing in the yard, they saw a hen.

"Oh Helen," Emily said. "Just look at that poor hen! How bad she does feel!"

"How do you know she feels bad?"

"Well, look at her shut eyes and her head and tail and wings all flopped. She feels as I did yesterday. Maybe oil…"

"I'll pour if you'll hold," said Helen.

The two girls carried the hen back to the nursery and administered their medicine. But the hen, it turned out, didn't much like castor oil. In her attempts to get away she flew much higher than Emily ever imagined a chicken could fly. She knocked over several things, spit castor oil all over the books in the bookcase, and managed to spread farmyard mud all around the room before Mrs. Crane arrived, her eyes burning and her voice like ice.

While Mrs. Crane cleaned up the mess, Emily tried to apologize: "I'm sorry, Mrs. Crane."

No answer.

"I wanted to help your hen. She's better. Perhaps it was only a little cuddling she wanted."

But even as she spoke, Mrs. Crane, following her nose, hauled two reeking starfish from the cupboard and dangled them as far from her nose as her arms could reach. Ten days earlier, Emily and Helen had found them under the boathouse, dressed them in doll's clothes, and then forgot about them. Somehow Mrs. Crane knew instantly who had instigated the whole incident.

"Such things never enter my Helen's head," she said. "Your mama is better; they are coming for you tonight."

∽

Dosing the chicken and dressing the starfish were just another sign of Emily's lifelong love for "creatures," especially birds. When she went to the family cow yard,

the rooster routinely sat in her lap, and she tamed ducks and chickens as well as a young crow she took from its nest. No doubt she was comforted by the fact that, if humans – adults and her older sisters – couldn't seem to understand her, her creatures always did, and she returned their affection with her whole heart.

And then there was the cow. At the back of the Carr property, between the old and the new barns, was the cow yard. Emily's older sister Elizabeth, called "Bigger," found it dirty and was a little afraid of the loose-limbed, saggy cow. Sister Alice, called "Middle," liked the cow all right but she equally liked to spend time with her huge doll family. Only Emily, who called herself "Small," wholeheartedly loved the red and white dreaminess of the cow and its cow yard. To her, it was a warm, motherly place, especially in the spring when baby creatures – chicks and pigeons, ducks and rabbits, and once even a splendid baby calf – were born.

The other being who always gave Emily pleasure was the imaginary friend who played with her among the white currants at the end of the garden. Emily claimed that the "dance" in her feet sometimes took her there without her even trying: to the family flower garden, through the vegetable garden, past the black currant and then the red currant bushes until she came to the single bush of white currants that, as they ripened, grew so clear that she could see the juice and the seeds inside.

This corner of the garden was a quiet, private place where people dumped the garden rubbish. A wild mauvey-pink flower grew here. It wasn't very

pretty as it struggled to grow up out of the rubbish, but it smelled so wonderful that butterflies and bees were always visiting, intoxicated by the smell. On a hot, sunny day when Emily went in among the butterflies and the pink blossoms and the glorious smell, she felt a part of it.

There was a boy there, who waited for her. He had a white horse and he brought one for Emily, too, and they winged in circles on their horses until butterflies and flowers and bee hum and blue sky and the hot sweet smell of pink all became one thing with the boy and Emily and the white horses in the middle – like the seeds in the white currants around them. That is, until some grownup called, and the boy and the horses went away.

Any outdoor place was a comfort to Emily. Away from her strict family, she roamed the woods and Beacon Hill Park. One of her favourite places was the family's lily field. This was the only one of her father's fields that had been left wild and "Canadian" and not made to look like a groomed English garden. The lily field was surrounded by a snake fence of split cedar logs laid crisscross over each other. Inside were fir trees and a few oaks, and the cleared ground underneath was thick with wild white Canadian lilies whose perfume Emily remembered with great fondness all her life.

When she was about twelve years old, something terrible happened between Emily and her father that revolted her and made her turn against him. No one knows exactly what it was. She never spoke of it to anyone until just before her death, and then she only called it "the brutal telling," but it had something to do with his explanation to her of sex and reproduction. It was unthinkable for a Victorian father to explain sex to his daughter. Perhaps he also touched her. Perhaps it was just the shock of the idea of sex to an extremely sensitive and protected young woman. Perhaps it was literally "a brutal telling" – blunt and explicit because of her stern father's embarrassment over bodily functions. Whatever happened, Emily was disgusted and her love for him changed.

She began to notice how he commanded everybody, how the family used her to soothe him – sent her out to meet him like a bone tossed to a dog whenever he left the family in a temper. She decided it would be good for him to have somebody to cross his will at times, and that the somebody would be her.

At first her father laughed, but when he saw she was serious, he was furious and even crueller to her, she thought, than to the others. It made Emily feel more and more distant from her stern family, and like many teenagers, although she felt guilty about it, she couldn't help criticizing them, finding her father and her eldest sister, in particular, to be hypocritical and cruel.

One day when she was especially angry at her father, she told her mother she wouldn't walk home with him any more.

"Child," her mother said, "what ails you? You have always loved to be with your father. He adores you. What is the matter?"

"He is cross, he thinks he is as important as God."

Mrs. Carr was shocked. In England, where she was raised, children were expected instantly to obey their parents, and the men of a family were its unquestioned rulers. She couldn't understand why Emily refused to just give in and be docile, like her sisters. But to soothe her youngest daughter, she only said, "Shall you and I have a picnic?"

"All to ourselves?"

"Just you and I."

Emily would remember it forever: how they walked through the garden and the cow yard into the wild, sweet smells of the lily field; how her mother took a large key from her bag and opened the padlock on the gate; and how the two of them then passed through the gate into Beacon Hill Park. When they came to a grassy clearing in the park, they sat in sunshine under a sweet-smelling mock orange bush, and for the rest of the afternoon as her mother sewed tiny stitches down long white seams (because it was unheard-of for a woman to sit idle), Emily made daisy chains. They didn't talk much – her mother was a quiet woman – but Emily was delighted for one afternoon to have her mother all to herself in this quiet, flower-scented, outdoor space.

Shortly after, when Emily was fourteen, her mother died of tuberculosis. Two years later, her father also died.

∽

Officially, the children – except for Clara, who was married – were now put under the guardianship of lawyer James Lawson, a family friend, but their daily care was left to the eldest sister, Edith.

Edith was thirty-two years old and had never married. Now she committed herself to raising the younger Carrs, and she no doubt did so the only way she knew how: sternly, following strict Victorian rules of proper behaviour. The other children were mostly obedient: Lizzie was very religious and wanted to be a missionary; Alice was patient and took the path of least resistance; Dick was still only eleven. But Emily was a passionate, strong-willed young woman who reacted to Edith's stern "care" with anger and a growing rebelliousness. Emily and Dick often got the riding whip on their legs – mostly for "insubordination" – not being polite enough to their elders.

Emily grew increasingly angry at what she saw as the hypocrisy of her family. On the outside, the Carrs appeared all kissing and sweetness. On the inside, she felt bitterness and resentment – certainly her own. Perhaps her view was influenced by the fact that she had always been the pampered youngest girl, their father's favourite. Now, their father had left everything to Edith, and Emily thought it wasn't fair. The house was meant to be a home for all of them, but Emily felt she had no rights and did not exist.

One day she went with several others for a boat ride with one of Edith's friends, a remittance man named Piddington, who was living with the Carrs for six months. In England at that time, if a family had a son who caused them difficulty, they sometimes got rid

of him by giving him a one-way ticket to Canada, together with a small allowance to keep him there. Like many Canadians, Emily thought these remittance men were parasites and intruders. She hated Piddington in particular because he teased her unmercifully. One day he humiliated her by rocking the little boat they rowed in until she was seasick in front of her friends. Emily was furious. That he called her "kid" made it even worse.

She snapped at him, "You are not a gentleman anyway! You are a sponger and a bully!" This was a great insult from a child to an adult, and Edith thrashed her for it until she fainted. But Emily refused to apologize.

It was a turning point. Emily told her sister, "I am almost sixteen now and the next time you thrash me I shall strike back." That was her last whipping.

After this, the whip was used only after school and on Saturdays when Emily took it down from its peg to go riding on the family horse, old Johnny. On those days, after Johnny had galloped past all the houses of Victoria he would slow down, stopping occasionally to sniff the bushes as if he was looking for something. Suddenly he would push through the undergrowth, as he found a hidden path that carried both of them away from the prying eyes of people into the woods. Here in some quiet clearing, hidden among the trees where no one could tell her how to be or what to do, Emily found peace.

Later she said, "Maybe after all I owe a 'thank you' to the remittance ones and to the riding whip for driving me out into the woods. Certainly I do to old Johnny for finding the deep lovely places that were the very foundation on which my work as a painter was to be built."

∽

The more isolated Emily felt from her family, the more she clung to the idea of painting. No doubt her sisters saw it as a mere hobby, a pastime. But Emily's dream of becoming an artist was nurtured by the French painter C.A. de L'Aubinière and his English artist-wife, Georgina, who probably taught her briefly in 1886.

She was in awe of them because they were the first "real" artists she had met – but she was oddly disappointed when she saw their pictures. Their landscapes did not seem at all Canadian to her, though Canada was so young that no one yet knew exactly what a "Canadian" painting should look like. In the European tradition, landscapes were panoramas of peaceful meadows with the odd tree, a cow perhaps, beside a quiet stream. They didn't look at all like the British Columbia Emily knew, where, just outside the city, endless acres of trees towered above an almost impenetrable undergrowth, and the cow was in her back yard.

Nonetheless, the two Europeans sowed a seed that made Emily sling an old pair of shoes across her rafters. Now, every time she had a little money she pushed it into the shoes. She had a plan.

One day when she decided she had had enough of her family, she marched downtown to the offices of her guardian, Mr. Lawson. He had many children as wards, and it was obvious to Emily, as he stared at her over the tops of his glasses, that none of them had ever come to see him before.

"What can I do for you, Emily?" he asked.

"Please, I want to go away from home. There is an art school in San Francisco – may I go there?"

Mr. Lawson frowned and said, "San Francisco is a big and wicked city for a little girl to be alone in."

"I am sixteen, almost." (In fact, she was eighteen. Emily always underestimated her age.)

"You do not look it."

"Nobody is allowed to grow up in our house."

Mr. Lawson replied, "Your sister is an excellent woman and has been a mother to you younger children. Is this art idea just naughtiness, a passing whim?"

"No," she assured him. "It has been growing for a long time."

He looked at her for a long minute. "It can be arranged," he said. And smiled.

3

Seeking Art

Artists from the Old World said our west was crude, unpaintable. Its bigness angered, its vastness and wild spaces terrified them.

— Emily Carr, *Growing Pains*

When Edith heard what Emily had done, she blackened, then suddenly smiled. Emily's leaving would finally give Edith some peace and quiet as much as it would give Emily an education. But as the responsible one, she couldn't let her sister simply disappear into the big city of San Francisco without a guiding eye.

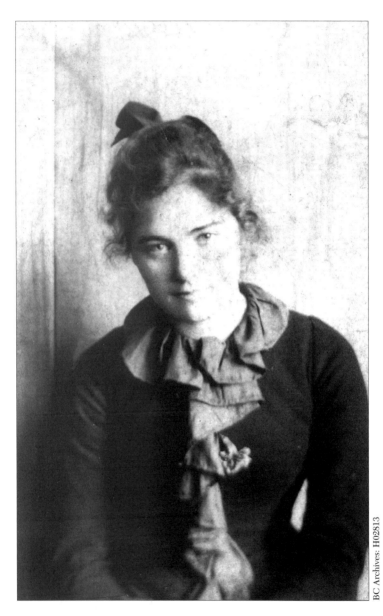

Emily, "green as a cabbage" as an art student
in San Francisco, about age 21.

"So you want to run away from authority? All right, I shall place you under the supervision of the Piddingtons!"

This was the same hated Piddington, the remittance man, who had made her seasick. Emily had forgotten that he and his wife were now living in San Francisco. When they left Victoria a few years before, she had been so glad to see them go, she hadn't cared where they went. But even the fact that she must live with them didn't dampen her joy at getting away from the ties of home and getting serious about her art, finally learning how to put together her love of art and her love of beautiful places.

Her ship sailed through the Golden Gate in the late summer of 1890, and San Francisco didn't look at all wicked as it rose out of the fog. When Mrs. Piddington led her away from the wharf, Emily carried only her old straw suitcase and a birdcage holding her pet canary, Dick, in full molt. The Piddingtons gave her a small room at the top of the private hotel where they lived.

The art school, called the California School of Design, was over the old Pine Street Public Market in a poor part of the city. From the street, Emily walked up a dirty stair to a dark, airless office. Beyond that was the school itself, a huge room lit by a skylight with large windows on the north side. Under them, grey screens divided the hall into alcoves. In one corner was a closed door with a sign: Life Class, Keep Out.

Some students sat in long rows with lap boards. These drawing boards had fronts that rested on students' laps and wide-spread hind legs that rested on the floor. Other students stood drawing at easels. They drew vegetable and animal still lifes so old they'd begun to rot, or they copied plaster images that stood on pedestals in the middle of the room.

The room was filthy. Blackened crusts of bread that students used for charcoal erasers dotted the floor. The air smelled of rats, and dead fish and birds, and rotting vegetables. Men and women wore smocks or painting pinafores smeared in layers of charcoal and paint. Emily bought charcoal and paper from the office and took her place in the long row of students under the windows. It wasn't quite what she had expected, but her education in art had finally begun.

The art taught at the California School of Design was old-fashioned. Though the director had recently studied in Paris, neither his teaching nor his own painting reflected the more modern art going on in France. Years later, Emily recognized that the art she brought home was "humdrum and unemotional," but she was beginning to learn her craft.

∽

Emily's nickname in San Francisco was "Dummy." Perhaps it was because emotionally she was still young and very, very shy. She couldn't bear – even for art's sake – to take Life Classes that would mean having to draw a nude model, but she loved the Wednesday morning outdoor sketching sessions when the students

set their easels up in cow pastures or on vacant lots. Outdoors, Emily found texture, shape, and space. As she sketched, half awake, half dreaming, she felt completely engaged with the landscape – body and soul.

Back in her boarding house, Mrs. Piddington watched Emily closely and called her "my dear" in the English way Emily hated because she was sure Mrs. Piddington didn't mean it. One day Mrs. Piddington wondered aloud how Emily could have managed to get through a huge crowd outside so quickly because when Mrs. Piddington left the house right after Emily, she couldn't move for all the people coming out of the cathedral.

Emily replied she'd found a nice, quiet side street: "The house doors opened so quaintly right onto the pavement," she explained. "All the windows had close green shutters; nearly every shutter had a lady peeping through. There was a red lantern hanging over each door. It was all romantic, like old songs and old books!"

"Stop it! Little donkey!" shouted Mrs. Piddington, and told Emily she'd just walked through San Francisco's notorious red light district.

"What is a red light district?"

"A place of prostitutes."

"What are prostitutes?"

That evening after supper, Mrs. Piddington pulled her chair so close to Emily's, their knees touched.

"Sit there, little fool," she ordered. "Your sister has no right to send you out into the world as green as a cabbage. Listen!"

Half an hour later, Emily crept up the stairs to her room, afraid of every shadow, every door. Mrs.

Piddington had told her that evil lurked everywhere in San Francisco. There were opium dens, she said, and drug addicts, kidnappings, prostitution, murders. The very sidewalks could open up and swallow a young woman and she would be taken into something called "white slavery" and never heard from again. Even the art school district, Mrs. Piddington warned, was very, very dangerous.

Emily locked the door tight behind her and crept to the window. As she stared outside at the "evil" city, she touched the canary's cage and felt his familiar nibble on her finger. After a while, she said out loud, "Dick, I don't believe it, not at all. If it was as wicked as she said the black would come up the chimneys and smudge the sky; wicked ones can shut their doors and windows but not their chimneys. There is direct communication always between the inside of the houses and the sky....San Francisco's sky is clear and high and blue." Mrs. Piddington had warned her never, ever to go off the main streets, never to speak to anyone and never to answer if anyone spoke to her. "I'll do that," Emily solemnly told her small, yellow bird. "But all the rest I am going to forget!"

No doubt Mrs. Piddington sent a letter back to Edith in Victoria, telling her that although Emily was working hard at school, she was taking liberties. She had not only discovered Grant Street but she was taking guitar lessons (had even joined a club) and only went to church where and when she felt like it. Perhaps the Carr sisters

found themselves free to leave Victoria for a year, or they were curious and wanted to share her adventure, or simply to be closer to Dick, who now had tuberculosis like his mother and was in a sanatorium in southern California. Perhaps they didn't trust Emily, alone in the big city with her silly plan to become an artist. Whatever the reason, in Emily's second year in San Francisco, Edith, Lizzie, and Alice all came to stay with her for one year. While they were there, they insisted she come with them on visits and family outings, and Emily worried that she wasn't working hard enough at her art.

At school, she moved from the drawing of plaster casts to painting still lifes under a professor with "ogle-eyes" who she was afraid of.

His main suggestions to her were, "Scrape, re-paint." Over and over. "Scrape, re-paint." Sometimes he just roared, "Scrape!" One day when he had done that four times in a row, Emily shouted back, "I have, and I have, and I have!"

"Then scrape again!"

In a fury she scraped the paint off her canvas and wiped the oily mess on a rag. Then she threw new paint onto the canvas, grabbed her paint box, and ran out of the studio in order to hide her tears.

When she had gone, one of the students told the teacher he was hard on the little Canadian.

"Too bad, too bad!" he said. "But look there!" and pointed to the painting. "Capital! Spirit! Colour! It has to be tormented out of the girl, though. Make her mad, and she can paint."

Before Emily could finish her course, she was called home by her guardian because, he said, she had

"played at art" long enough. Probably there was not enough money left to support her. After three years in San Francisco, Emily returned to Victoria.

∽

Emily's sisters, although they loved her, continued to be both over-protective and critical of her, the baby of the family, and Emily was often cross with them. Her sisters were among the founders of the Young Women's Christian Association, the YWCA, and because there was not yet a headquarters in Victoria, people often came to the Carr house to talk and pray. Her sister Lizzie wanted to be a missionary, and Emily hated it that their house was now full of what she called "the missionary blight."

Proper Victorian women didn't usually work outside the home, but the Carr family was now in what was called, "reduced circumstances." With four sisters at home and brother Dick in hospital in California, Emily had to earn an income, and although at first she felt a little afraid of her pupils, she began to teach drawing to children in the family dining room.

But the room was too dark. The children created mess and noise and there was trouble with her sisters after every class, and so, feeling brave after her taste of independence in California, Emily asked Edith if she could use the loft of the old cow barn for a studio.

Reluctantly, Edith agreed. The barn was in poor repair. Emily used all her money to pay a carpenter to fix the leaky roof, but still there was a problem because the loft, like the dining room, didn't have enough light

for painting. With no money left, Emily and Bong, the family servant, tackled the problem themselves. They fitted two old windows into the roof to make a skylight. They fixed the leaks, put in a stove, blocked the pigeon holes, and burlapped the walls. Soon, even if it smelled a bit like cow, Emily was cozy and warm with her students above and the warm, snuffing noises of the old cow chewing below. Outside on the roof, a beautiful peacock began to come to preen, using the dormer window as his mirror.

Before long there were several students attending Miss Carr's art classes in the loft above the cow barn. Emily was a natural teacher, almost as playful as the children. If they got too noisy, she would drop through the trap door into the cow's manger, creep through the barn, and run up the studio stairs to surprise them and set them back to work.

She also continued her own work, changing from the art school focus on portrait and still life toward landscape. In those days in Victoria, the only place an artist could exhibit was among the crocheted afghans and fresh-baked pies at the Victoria fall fair, and twice, Emily's pen and ink drawings won first prize.

∽

In the summer of 1898, Emily took the steamer *Willipa* to Ucluelet on the west coast of Vancouver Island to visit her sister Lizzie. She stayed in the small mission house near the reserve where about two hundred members of the Ucluelet band of the Nootka (now called Nuu-chah-nulth) nation lived.

To her, this way of life outside the city was all new. She loved having so few rules, being on the shore between the vast calm of sea and of forest. She loved being outside all day in the fresh air, eating fresh fish, wandering as she liked. Time slowed down and people let her do mostly as she pleased. The prisoner of strict Victorian rules and manners could feel her chains being loosened.

One day soon after she arrived, the chief – who was said to be a "reader of faces" – visited her in the missionary's house. He sat on top of the medicine cabinet, his hands gripping the edge, elbows braced, and stared hard into Emily's eyes. After a while he looked up, said a few sentences in Chinook Jargon (the trading language), and returned to the village.

Emily asked a little nervously, "What did he say?"

"That you had no fear," the missionary told her, "that you were not stuck up, and that you knew how to laugh."

The native people gave her the name "Klee Wyck," the Laughing One, and she quickly made friends in their community. Without speaking either Chinook Jargon or the local native language, and using only gestures and facial expressions, she received permission to visit them and sketch in the great houses that were home to several families. But it never occurred to her to paint the forest. The Canadian forest was still too vast to imagine trying to express it in paint.

Living conditions on the reserve were poor. There was little work for the men, and many people were fatally ill with German measles, whooping cough, or

tuberculosis. Residents were sick at heart, and perhaps because of this, there was widespread drinking and gambling.

Emily felt great sympathy and she firmly blamed Europeans for the natives' dispirited condition. She especially blamed the missionaries, who called traditional ways "ungodly" and taught native people to be ashamed of their heritage.

Her sympathetic response was unusual for the time. Most white people in British Columbia, although they had relied heavily on the skills and kindness of First Nations people to help them adjust to a new country, by the 1870s were hostile, and regarded most native people as "drunks and idlers."

Her visit to Ucluelet was the first time Emily found comfort and pleasure in the company of First Nations people. Unlike most of the white people she knew, native people left her alone. She didn't feel lectured or scolded or disapproved of. Mostly they accepted her presence in silence, and so, in their company she could focus on her passion – her art.

On the steamship home, Emily became friends with the ship's purser, William "Mayo" Paddon, son of an Anglican priest in Victoria. Mayo soon became a frequent visitor to the Carr house. He and Emily walked and talked together through the park and along the cliffs above the sea. Emily even attended his church, the Holy Saviour. Mayo, who was deeply religious, was drawn to Emily because he found her the same, in

spite of her rebellion against what she saw as the hypocrisy and mistakes of the church.

He proposed marriage more than once, but Emily turned him down, although one time she almost changed her mind. It happened when she told him about a time when Edith was furious at her (again) and trying to shame her. Edith had said, "Poor Mother worried about leaving you. She was happy about her other children, knowing she could trust them to behave – good reasonable children – you are different!" It hurt Emily's feelings badly, and for years she cried over it until Mayo whispered in her ear, "Don't cry, little girl. If you were the naughtiest, you can bet your mother loved you a tiny bit the best – that's the way mothers are." For that, she said, she almost loved him.

But not enough to marry him. Apart from the fact that all her life she was bashful about her body and squeamish about sex, Emily, like every Victorian woman, knew that her duty when she married was to bear children and care for her husband and family. (Partly, a woman had no choice but to bear children; these were the days before birth control.) At best, the woman's own interests – like art – must take second place. Emily wasn't ready for that. Besides, by now there was enough money in the shoes. One of her friends from Victoria, Sophie Pemberton, had had great success studying in England and was now making her artistic debut in Paris. In 1899, Emily announced to Mayo and her family, "I'm going to London to study!"

The trip was a difficult one. Emily could not go on the water without being seasick. For the entire voyage to England she was violently ill.

4

Breakdown

Have you ever rubbed your cheek against a man's rough tweed sleeve and, from its very stout, warm texture against your soft young cheek, felt the strength and manliness of all it contained? Afterwards you discovered it was only the masculine of him calling to the feminine of you – no particular strength or fineness – and you ached a little at the disillusion and said to yourself, "Sleeves are sleeves, cheeks are cheeks, and hearts are blood pumps."

– Emily Carr, *Hundreds and Thousands*

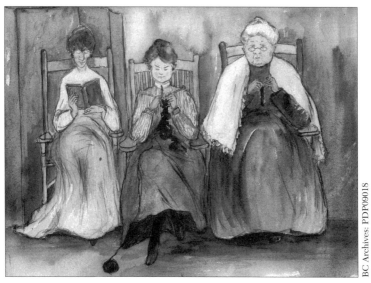

When the World Gets One Too Much

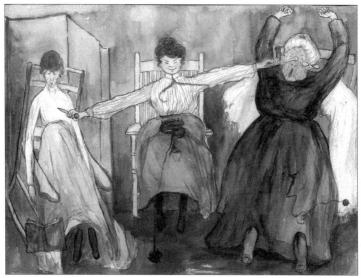

When the World is Midling Fair

Emily (centre) could always sketch and draw cartoons
that made light of even her darkest moments.

It had been arranged in Canada that Emily would be the paying guest (this was a polite name for "boarder") with her British aunt, Amelia Green. Aunt Amelia met her at Euston station in the middle of a blazing hot London summer. Emily had never seen such a huge city and was amazed by the "writhe of humanity...as indifferent to each other as trees in the forest." Both trees and crowds made her feel insignificant and she immediately ached with homesickness; London's overcrowding and its stale, smelly air were hateful to her. She begged Aunt Amelia to help her.

"Miss Green, is there any place one can go to breathe?"

"There are London's lovely parks."

"Just as crammed – just as hot as everywhere else!"

Miss Green was a little surprised. Her idea of a nice time was to go stand on a street corner and watch lords and ladies passing by. If you were very, very lucky, you might even catch a glimpse of Queen Victoria.

"Dear me!" Miss Green exclaimed. "You Canadians demand a world apiece. I have offered to take you to Hyde Park, show you our titled people riding and driving, but no, you Canadians have no veneration for titles."

No. Emily wanted only quiet, outdoor space. When she persisted, Aunt Amelia finally suggested London's Kew Gardens, the largest botanical gardens in the world. Here, there were trees and plants from almost every part of the globe.

When she arrived, Emily was at first put off by all the "Thou shalt not..." signs: "No person may carry a

bag, parcel, or basket into the gardens," they said. "You must not walk upon the grass, or run or sing or shout." Emily strode along the paths, deeper and deeper into the Gardens. What had those signs said again? Oh yes: no bags, no singing. Defiant as ever, she clutched her bag, and sang her very loudest.

When she found a small grove of Canadian pines and cedars, she was delighted. Their needles, when she rubbed them between her fingers, smelled like home.

∞

She registered at the Westminster School of Art, located just behind Westminster Abbey in the heart of London. Emily probably chose England over France for her art studies because there was no language problem and because her sisters would be less resistant to her going to the "old country" familiar from their parents' stories, than to the "foreignness" of France. But it was not a happy choice. In San Francisco, Emily's status as British (as the Americans then saw Canadians), had made her feel somewhat equal to her American friends, but in class-conscious London, she was reduced to being a mere colonial, and a shabby one at that. It increased Emily's feelings of being unwelcome and uncomfortable in this huge city.

Also, English art was traditional and conservative. The newest ideas were happening on the continent, and though the Westminster school had once been England's best art school, it wasn't any longer. The instruction Emily got here was to be no better than in San Francisco – and that hadn't been good. Her

unhappiness with the City of London quickly deepened to loathing, and she was further depressed when she heard of the death of her brother, Dick, from tuberculosis.

∽

In spite of homesickness, Emily made some friends at school, but her best friend was Mrs. Redden, the aunt of Canadian friends. Marion Redden was a kind, practical Scot who had spent her married life in Canada and now lived in London with her son. She was as strong-willed and outspoken as Emily, and they often fought, but Emily soon began to spend most of her Sundays with the Redden family.

At the beginning of her second year, Mayo Paddon, her Canadian suitor, came to visit. When Emily arranged to meet him at church one day with Mrs. Redden, Mayo and Mrs. Redden liked each other immediately, and the older woman, with many "dear me's!" and twinkling eyes, arranged to let the two Canadians walk home together without her.

After Mrs. Redden caught him one night on his knees in front of the fire, warming Emily's cloak and patting the collar as if it were a kitten, she called him "The Knight of the Cloak" and liked him more than ever.

Not Emily. Five times a week Mayo asked her to marry him, and five times a week she said "no." As he got sadder, Emily got crosser. It made her even more angry that Mrs. Redden continually urged Mayo not to give up, and urged Emily to say "yes."

One of Emily's favourite places in London, and one she must have shown Mayo, was the zoo in Kew Gardens. Here she would sit for hours watching the animals. Once they grew used to people, she thought, perhaps they did not really mind being kept in cages. Most of them seemed "merry" and all of them were "well tended."

Emily knew what it was like to feel caged. Since childhood she had paced, eager to escape the bars of her family and her narrow Victorian culture. She had had a taste of freedom in California, but here the cage was subtle and enticing and right in front of her: small things like changing her accent to sound less colonial, larger things like the pressure to choose marriage over art, to yield to traditional values and to be – in the end – "well tended" if not exactly "merry."

Mayo Paddon offered her security, companionship, and family. She truly liked him, and she was now nearly twenty-nine years old – almost an old maid. But her choice was all or nothing. If she said "yes" to Mayo, her life would be spent looking after husband and children and house, and only if she had spare time would there be a place for art.

Emily hated London but she would not marry Mayo and let him take her away. She had come here to study painting. Finally she told him to, "Go away, Mayo; please go away!"

And he did.

∽

Years after she refused Mayo's offer of marriage, Emily mourned about "that poor love I deliberately set out to

kill." She thought it was a "dreadful thing to do," but she didn't regret it. "I did it in self-defence," she said, "because it was killing me, sapping the life from me." Once and for all she had said "no" to what was supposed to be a woman's highest calling: marriage and family. Emily chose art, and now she committed herself to study, day and night, more intensely than ever.

But an old injury to her toe was making it harder to walk and causing her terrible pain. At first Mrs. Redden scolded her for whining – "You homesick baby! Stop that hullabaloo! Crying over a corn or two!" – but when she saw it was serious, Mrs. Redden called in her surgeon-cousin to examine the ailing foot.

The toe was fractured and had to be amputated, and it was very, very slow to heal. For the rest of her life Emily would carry a camp stool with her when she sketched because she couldn't paint standing up.

This time it was Alice who followed her from Victoria for a visit. At first Emily was excited. She pinned her best artwork on the walls of their rooms and waited eagerly for her sister to comment. But Alice didn't even look. She didn't ask about Emily's work, either. Finally Emily said, "Not interested in my work, are you?"

"Of course," Alice replied, "but I have not seen any."

Emily pointed at the walls and said bitterly, "I suppose you thought these were wallpaper?"

Her family had never understood or encouraged her art, but it hurt her badly that even her favourite

sister didn't care. Now Emily decided she would "seal it from everybody." She would keep the importance of her painting hugged closely to her own heart.

When Emily's London classes finished, the two sisters left the city so Emily could study in small villages and sketch outdoors. Alice returned to Canada, but Emily's health, which hadn't been good in London, got worse. She developed headaches and gained weight.

She was not happy. She was working too hard, and with so little money she was probably not eating properly. By now she also realized that the most exciting ideas in art were not in England; she should have gone to Paris or Rome. It didn't help that Julius Olsson, her teacher at St. Ives in Cornwall on the south coast of England, forced her to paint sun and sand until she thought her head would split.

But it was in St. Ives that Emily first painted forest. Whenever she could, she escaped the blazing sun on the beaches to sketch in the cool shade of Tregenna Wood, above the village. Olsson denounced the work she did here as "Neurotic! Morbid!" but his assistant, Algernon Talmage, encouraged her. "One works best where one is happy," he told her.

Olsson was a good teacher, but like most teachers of the day, he greatly favoured his male students. He invited them to his studio, discussed his own art with them, and treated them like fellow artists. When Mrs. Olsson had her husband's favourite students to tea, Emily was not invited. Emily told the other students she didn't care, but it was one more humiliation that bit into her and fed her self-doubt.

∽

Her health continued to get worse. Emily was happy to be in the country and was learning some new things from her teachers, but she was terribly homesick. Everywhere she went in England she felt harshly judged because she was not only from the colonies, but a woman. Even her friends in London, the Reddens, didn't take her art seriously.

She was over thirty years old and the pressure must have been intense. She must have begun to question herself. What if everyone else was right? Was her plan to be an artist just a silly mistake? If she wasn't going to marry, what could she do? She hadn't learned enough yet about art, and she refused to leave England before she got what she came for. Finally, emotionally and physically exhausted, Emily had, as she put it, a "crack up."

Sister Lizzie, hearing of Emily's illness, came from British Columbia to be with her. But Lizzie was emotionally in as bad a state as Emily. She also represented all the forces of conformity that Emily was fighting to escape, and her efforts to help – including having prayers offered for Emily at the local church – instead of calming Emily, roused her wrath and increased her anxiety even more. By now Emily was having terrible headaches and was experiencing fatigue, depression, vomiting, stuttering, and numbness on one side.

On January 12, 1903, Lizzie took Emily to the East Anglia Sanatorium for treatment and returned alone to Canada.

∽

The Sanatorium was a hospital mainly for people with tuberculosis but there was the occasional patient, like Emily, whose complaint was entered in the hospital's "Doom Book" as "hysteria." This was a form of illness commonly diagnosed for women at the time. It was thought to be the result of women's emotional nature and their denial of their "God-given" and socially ordained roles as sexual beings and mothers. Today, such symptoms would be recognized as a response – by both men and women – to unendurable stress. The Sanatorium, or San as it was called, was run by Dr. Jane Walker, who was experimenting with open-air treatment for tuberculosis.

Emily arrived in the middle of a snowstorm. The front wall of her room was open from the ceiling to a foot above the floor. Above her bed, small windows opened into a corridor that was all open windows. As the wind roared through, a nurse shook the snow off the bedspread before her Canadian patient could crawl, shivering, into bed.

The doctors' prescription was for complete rest and freedom from worry for one year. Emily could do some sketching but no painting. Any emotional stimulation, they said, was harmful, so tears as well as laughter were discouraged. According to Emily, "Even thinking was prohibited." Mostly, she stayed in bed and ate. Occasionally she was allowed to draw cartoons and write silly rhymes to pass the time and to get her revenge on nurses she didn't like. "I was not always polite," she remembered later.

Her one joy was that she was allowed to raise birds. The beautiful songs of some English birds, she thought, were the only thing England had that Canada did not. Her plan was to take songbirds back to Canada with her and release their offspring in the wild. Today, people could tell her such experiments don't usually work, but at the time, Emily thought it was a splendid idea.

When spring came she stole several nests, eggs and all, from nearby bushes. Her books said that if her hand with its juicy worms was the first thing the young birds saw, they would accept her as their mother.

When her nestlings hatched, she poked food into their mouths every two hours with a tiny pair of pincers. Other patients helped her. After their walks they left small offerings of ants and grubs, beetles and worms on Emily's windowsill. Kitchen maids donated rhubarb and cabbage leaves that, when laid on the grass, attracted snails and other bird treats. She was christened "Birdmammy" by a doctor who found her asleep one day with five baby bullfinches cuddled under her chin. When they began to fly, the birds were put into a large aviary in the yard.

Emily's birds became the San darlings. If a patient was feeling bad, the nurse would ask Emily to, "Lend the soldiers!" and head off with a cage full of birds to cheer the sad one.

Today, some would criticize her for capturing and raising wild birds, but these small creatures and their songs were the single thing that brought her – and many others in the hospital – joy. "But for birds," Emily said later, "I doubt I could have stood it."

All her life she kept large numbers of animals –
wild and domesticated – as a way of connecting to
nature. They were also an outlet for her devotion.
Emily was never a mother but she had a strong mater-
nal instinct. If she couldn't have her own babies, she
would have these wild ones who quietly loved her and
didn't require her to sacrifice her art.

∽

After more than a year, everyone's special gentleness to
her – and the fact that she was no better – made Emily
begin to wonder if she would die. When simple rest
and good food didn't help, the doctors began to "treat"
her by alternating under- and over-feeding and giving
her cold and hot baths. When she still did not get bet-
ter, they proposed, as a last resort, a more severe and
experimental form of treatment. Before she agreed,
Emily called her doctor.
"May I get up?"
"You are not able, Mammy."
"Something I must do."
"Your nurse is here."
"No one can do this but me."
Emily had hoped to take her birds back home.
Now, sadly, she put them one by one into a box and
asked for the doctor again.
"The birds, Doctor. There in the box. Chloroform
them."
The doctor was shocked but Emily insisted,
"Quick, they are waiting."
"Free them, Mammy!" the doctor urged.

"They do not know freedom," Emily replied. "Villagers would trap them – tiny cages – slow starvation....Broken necks, fertilizer for cabbages! Please, Doctor. I love them too much." And the doctor did as she was asked.

∞

Now Emily gave herself into the hands of the doctors, who drowned her in huge amounts of food, massage, and electrical treatments – four hours each day for the next six weeks.

Although Emily is vague about this time and the hospital records have been lost in a fire, the "electrical treatments" were some form of electro-shock therapy, though probably not the extreme kind we know today. Doctors at the time were experimenting with different kinds of electrical equipment, including an electric massage device that produced a buzzing sensation on the skin. Verses Emily wrote later in which she compared the treatment to sitting on a bee hive, seem to agree with this.

When Emily finished the experimental treatment she was declared "cured" and told never to go near London again. It was big cities, it seemed, that made her sick. She was as rooted as any pine tree in wild Canadian soil. Without it, she seemed to fade.

Still, she wasn't well. After eighteen months in the sanatorium she was depressed. Her struggle to paint had become a distant dream. She cared about nothing and she was afraid the doctors had killed her enthusiasm for painting. When she left the sanatorium she

returned to the last village where she had studied and, not knowing what else to do, wrote about her time in the San as a series of silly verses illustrated with sketches. She cried the entire time she was writing it.

In June 1904 Emily caught a ship back to Canada. She was thirty-two years old, depressed, and convinced that her five years of study in England had been a complete failure.

5

Digging In

> Every year Sophie had a new baby.
> Almost every year she buried one....By the
> time she was in her early fifties every child
> was dead and Sophie had cried her eyes
> dry.
>
> – Emily Carr, *Klee Wyck*

On her way home to Victoria, Emily stopped for eight weeks to visit friends in the Cariboo district of British Columbia. Here she began to get better in the clean air and open spaces of B.C. ranch country. Her friends taught her to ride a horse astride instead of in the more "ladylike" sidesaddle position that women

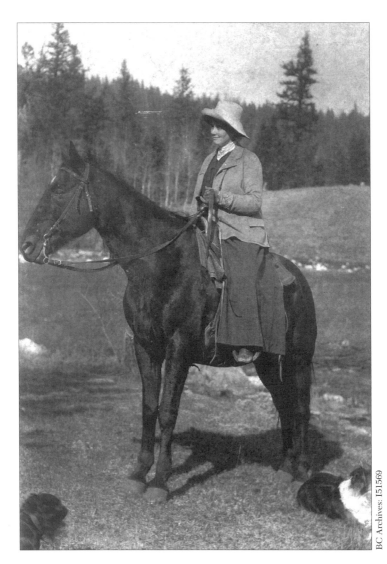

Once again, Emily defies expectations of how "nice" ladies should
act, by learning to ride her horse astride, instead of sidesaddle,
while in the Cariboo district of British Columbia.

were expected to use, and she spent most of her time outdoors, riding.

When she returned to Victoria, Emily seemed to her family more strong-headed than ever. Not only did she shock the entire neighbourhood by riding astride, but she'd also picked up the unladylike habits of smoking, swearing, and playing cards, and she refused to attend church regularly.

Most of her childhood friends had left Victoria. Sophie Pemberton was back in Victoria but she had married and now had other interests than art. Emily felt restless. She was deeply disappointed in how little she had learned in England and she was still not completely well. Her sisters were busy with their own lives: Lizzie was going to study physiotherapy in Seattle; Edith worked on charities; Alice had opened a new kindergarten. Emily sought comfort by heading back to Ucluelet for a while; then she and her birds, squirrels, chipmunks, and Billie – a sheepdog one of her sisters gave her – all moved to Vancouver, where she was hired to teach the Vancouver Ladies' Art Club.

Things immediately went bad. Knowing she had just returned from study "abroad," the ladies assumed their new teacher would be witty, clever, and smartly dressed. Instead, they got a shy, fat, dowdy creature who smoked and swore at them. They had hired her to look at their paintings and give criticisms, suggest ways to improve, but it quickly became clear they didn't take their art seriously enough for Emily Carr. Ladies came to class late. They re-posed the models. One refused Emily's art criticisms altogether.

Being Emily, she took her revenge not by fading away but by going on the offensive. She considered their casual attitude to art a sacrilege and called them "vulgar, lazy old beasts." When they snubbed her, she gave extra-harsh criticisms of their work. After one month, they fired her. Emily decided that from now on, she would concentrate on teaching children, who were easier to get along with.

∽

Children taking classes from Miss Emily Carr at 570 Granville Street ran up the marble stairs to the second floor, past the Men's Conservative Club and into a studio jammed with tables, easels, flowers, and animals. From one corner might come the tantalizing squeak of chipmunks and squirrels, busy building nests. The masked raccoons could be daintily washing their dinner while Jane the parrot and Sally the cockatoo screeched happily over the din. In the middle of it all, Billie the English sheepdog curled like a warm white rug for any child who needed a moment of quiet snuggling before returning to the fun of sketching a nursery rhyme or painting one of the bright bouquets at the window. Sometimes Miss Carr released the two white rats to play on the table. Then everyone grabbed their bread-erasers to save them from becoming a rat's dinner. There was always tea, and snacks, and laughter.

On warm days she paraded her little company through the hallway, down the stairs, and along Georgia Street to the Vancouver wharves or to Stanley Park to sketch. Each child carried a camp stool and easel, and

one held the basket from which Sally the cockatoo happily screeched, "Sally is a Sally! Sally is a Sally!"

When she wasn't teaching, Emily worked on her own paintings, but her favourite activity was to lose herself and Billie on one of the many paths that threaded through the densely treed Stanley Park. She especially loved the solitude of a grove of seven huge cedars called the Seven Sisters. Although she no longer went to church regularly ("God got so stuffy squeezed into a church," she once said) she was finding her holiness outside.

One day there was a knock at her studio door. She opened it to find a slim, barefooted woman about thirty years old with a baby on her back and two small children beside her. Sophie Frank was a Coast Salish woman who sold her handwoven baskets door to door. Emily especially liked one but she hadn't enough money to buy it. Sophie offered to exchange it for used clothes the next time Emily came back from Victoria. In the meantime, she left the basket.

Emily was moved by the native woman's trust in her. When she brought back a collection of used clothes that Sophie found acceptable, the two women began a lifelong friendship. Whenever Emily lived in Vancouver, Sophie dropped by for tea. And when Emily felt lonely she visited Sophie in her village on the north shore of Burrard Inlet. She would take the ferry across Burrard Inlet and the two women would visit in Sophie's three-room house beside the Catholic

Mission. In spite of Emily's poor Chinook and Sophie's broken English, they laughed easily together. Often there was a new baby to play with. Sometimes they sat silently on the church steps, watching the ferry cross to the North Shore, the canoes out fishing, and the children playing on the beach.

Sometimes Sophie put on her best skirt of plaid and black velvet and tied a yellow scarf around her head, and they would visit the graveyard with its collection of tiny gravestones belonging to Sophie's many dead babies. One of them was named after Emily. Then they might walk to the church where Emily, although she was not Catholic, had the priest's permission to cross herself with holy water and kneel with Sophie in front of the candles burning on the altar.

A portrait of Sophie hung in Emily's studio. "There is a bond between us," Emily said, "where color, creed, environment don't count. The woman in us meets on common ground and we love each other."[3] They remained friends until Sophie's death in 1939.

∽

The other way Emily eased her loneliness was by spending weekends with her sisters in Victoria. As long as they stayed at a certain distance from each other, they all seemed to get along.

In 1907, Emily and Alice took the Alaskan cruise on which Emily first saw the totem poles of Alert Bay and Sitka. It was on this trip that she decided to paint

3. Paula Blanchard, *The Life of Emily Carr*, p. 108.

what she saw as the vanishing heritage of British Columbia's First Nations.

The next summer and again in 1909 as soon as school ended, she boarded a steamship and, with Billie for company, sailed up the coast of Vancouver Island to Alert Bay, Campbell River, and to other Kwakwaka'wakw settlements that had a strong tradition of carving.[4] On the mainland she travelled to Sechelt, Hope, Yale, and Lytton. She painted the large native community houses with their dramatic faces and the totem poles, always trying to be as precise and photographic as possible, because, she felt, she was working "for history." By this time Emily was signing her paintings, "M. Emily Carr" or "M. Carr" or "M.E. Carr" to carefully distinguish herself from the other "E. Carrs," Edith and Elizabeth. Toward the end of her career her paintings were usually signed simply, "Emily Carr." By then there was no doubt, there was only one.

In 1908 Emily was a founding member of the British Columbia Society of Fine Arts, but many of the artists there found her abrasive and hard to get along with. In fact, she was beginning to get a reputation as being a bit odd. She didn't seem to care what people thought of her – or rather, she defied people to think whatever they liked. For Vancouverites, this was probably her greatest sin. Once, when a student caught her scrubbing her studio floor dressed in her bathing suit, Emily only laughed. People found it strange that she was always surrounded by animals.

4. At the time, the people there were called Kwakiutl, which is the anglicized form of Kwakwaka'wakw, pronounced Kwak-WAK-ya-wak.

And then there was her subject matter. Other artists had painted native villages before, but Miss Carr, they said, actually lived with the Indians while she painted them! Emily, who liked to shock, didn't object to any of the growing talk about her. Most Indians seemed to accept her more easily than white people did, and she was always happier in small villages and in the forest than in big cities.

Vancouver art critics praised her work, but Emily wasn't happy with it. She knew she had much more to learn. She had been to London. Now, she decided, she had saved enough money from her teaching to go to Paris where the "real" art was taking place. Alice would go with her as her translator. They arrived in Paris in August, 1910.

6

Finding Colour

> I tramped the country-side, sketch sack on shoulder. The fields were lovely, lying like a spread of gay patchwork against red-gold wheat, cool, pale oats, red-purple of new-turned soil, green, green grass, and orderly, well-trimmed trees.
>
> – Emily Carr, *Growing Pains*

As soon as they settled in their flat in Montparnasse, Emily and Alice went to see the man to whom Emily had been given a letter of introduction. His name was Harry Gibb. At first Emily was shocked when he showed her his "modern" paintings. Alice

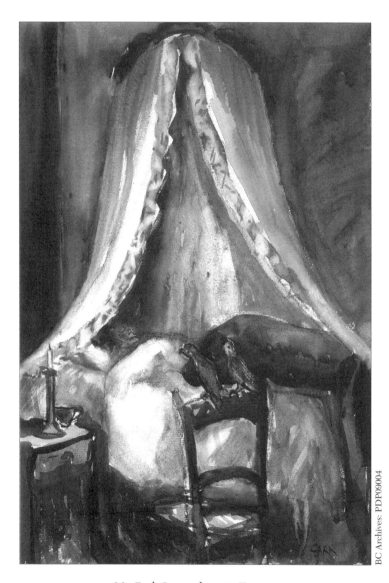

My Bed, Somewhere in France.
Emily is fascinated by the New Art she learns in France,
particularly its use of bold colour, surging rhythm, and
distorted perspective to convey emotion.

couldn't even bear to look. The figures weren't realistic but distorted – and they pulsed with wild, unnatural colour. This was the "New Art" that everyone either loved or hated, and it was what Emily had come to find.

After the first shock, she found the pictures exciting. They made traditional art look dull and unconvincing. She wanted to know how she too, could paint in this style. Gibb recommended the Académie Colarossi where Whistler, Rodin, Van Gogh, Gauguin, Modigliani, and Matisse had all studied and where male and female students could work together. At many schools, this was unacceptable, but Gibb thought Emily would benefit from working beside what he called "the stronger work of men." Emily had found another reluctant mentor who didn't have a high opinion of the work of women artists.

But he was the perfect contact. Paris in 1910 was bristling with painters, writers, and artists of all kinds who would one day be very well known, and Gibb knew most of them. He had sold Henri Matisse's first painting and exhibited his own works with artists like Pierre Bonnard, Georges Seurat, and Edouard Manet. Gertrude Stein, Georges Braque, and Matisse were among his close friends.

Emily and Alice lived in the Latin Quarter, one of the most exciting parts of Paris at this time, but, as if it had taken all their courage and adventurous spirit just to get there, they were strictly conservative in their socializing. They didn't seek out the renegade galleries that were showing Matisse and Gauguin. They didn't eat at nearby local cafés where the Russians, Leon

Trotsky and Wassily Kandinsky, played chess or where Modigliani, Braque, and Picasso ate and argued. And they didn't seek out the galleries where the paintings of artists like Matisse, Duchamp, and Léger were shocking the art world.

Instead, they socialized at the American Student Hostel Club and ate only at the cafés where other English and North Americans ate. Partly, no doubt, this was because of language; Emily said Alice could speak French but wouldn't, and Emily couldn't. Whatever their reasons, they stayed carefully sheltered behind a curtain of English.

∽

Art school was another matter. At the Académie Colarossi, Emily, at thirty-eight the oldest in the class, didn't speak a word of French, and no one there spoke English. She could only understand the critiques she was given through the hand and facial gestures of the teacher. Also, at this time the class was all men, and she missed other women. "There was not even a woman model," she noted.

One day she heard a good Anglo-Saxon "Damn!" behind her and turned to see a student furiously rip the lining from his pocket to use for a paint rag. They made a deal: Emily would provide clean paint rags in return for translation services. In this way she found out the teacher thought she had a good colour sense and was doing very well.

But the English speaker didn't attend class often enough, so she moved to the studio of a Scottish artist,

John Fergusson, where English was not a problem. Fergusson had been greatly influenced by the Fauve school. These were the artists, like Matisse, who used distorted perspective and brilliant colour to convey emotion. A critic once called them "wild beasts" or "fauves" in French, and the name stuck.

Emily was moved by their violent colour, their surging rhythm and design, but, as if she suffered from an allergy to large cities, she again became ill. She spent weeks in hospital and a month in Sweden with Alice while she recovered. Back in France (after Alice returned home), she avoided Paris and studied with Gibb in the villages of Crécy-en-Brie and St. Efflame in Brittany in northern France.

Gibb was deeply impressed by Emily's painting. His wife told Emily she had never seen him so interested in a student's work, and Emily in turn was inspired by his teaching. Gibb didn't merely copy the landscape he saw in front of him; he painted what his imagination saw, in the colours Emily found so exciting.

She recognized his "keen interest" in her work and valued his criticisms – but she was irritated that, like Olsson in England, Gibb never invited her to tea or showed her his own work or invited her to join his other students. Finally she asked, "Why do you never allow me to see your own work now, Mr. Gibb?"

"Don't have to," he replied. "Those others don't know what they are after, you do. Your work must not be influenced by mine. You will be one of the painters, – women painters – of your day."

It was high praise and Emily was delighted, though she noted his qualification. "He could never let

me forget I was only a woman," she mourned. But Gibb taught her well, and encouraged her to bring out her B.C. totem pole paintings and repaint them using some of his methods and colours. His only complaint was that she worked too hard.

∽

A few weeks before she returned to Victoria, Emily left Gibb to study in another French seaside town, Concarneau, with her only woman teacher, an artist named Frances Hodgkins. The two women had a lot in common: Hodgkins too, was escaping the conservative art community in her native New Zealand. She was single, about Emily's age, loved animals and the French countryside, had painted the native Maoris of New Zealand, and supported herself with teaching and painting. The two women were also similar in temperament; both had a keen sense of humour and a caustic temper. Each had also turned down a suitor in order to pursue her commitment to being an artist.

With Gibb, Emily had painted strictly in oils. Now Hodgkins, a superb teacher and brilliant watercolourist, insisted Emily return to the watercolours she had been using in Canada. Under the direction of Frances Hodgkins, Emily did not revive her old muted palette but adopted her new teacher's Fauve-bright colours. She also learned to use, as Hodgkins did, a strong, dark line to outline forms and to paint the large features of a scene without getting distracted by detail. For the first time, Emily moved clearly into the realm of "modern" art by painting how a scene *affected* her,

rather than trying to transcribe a literal picture. It was an important breakthrough and something she had been striving for.

Before she left Paris in the fall of 1911, two of Emily's paintings were hung in the *Salon d'Automne*, a prestigious salon for new, modern artists. This was the same exhibit that introduced the Cubists – Matisse, Jourdan, Léger, Rouault, and Valminck – to the art world. Emily's two small paintings aroused little notice, but it was an important achievement for her, and a validation. She went home proud of her developing style and of how her art had grown and been acknowledged in France. More, her exposure to the radical artists and art ideas she met in France showed her that defiance could be an acceptable part of an artist's career. This would make her stronger for what was to come.

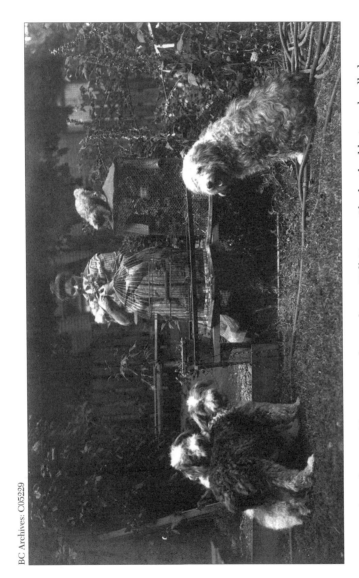

Emily and some of her pets, in the garden at Hill House. She loathed being a landlady. Her "creatures," especially her kennel of English bobtail sheepdogs, comforted her.

7

Buried in Dirt

> Mind you, I could make any house do me
> but some places don't belong to your type –
> squares in rounds and rounds in squares...
> There must be a place somewhere for me.
> – Emily Carr, *Hundreds and Thousands*

When Emily returned from France she felt stronger "in body, in thinking, and in work" than she felt after England. She had learned invaluable lessons about colour, form, and how to say what she wanted with shape and colour. She knew the work she had done there was her best to date, but it was radically different from what was traditionally considered

"good art" and when she showed it to her family and close friends, they turned away in embarrassed silence. As Emily recalled, "One [sister] was noisy in her condemnation, one sulkily silent, one indifferent to every kind of art."

The following spring, in Vancouver, she put on a show of her French paintings. Her bold colours were unlike anything people had seen before. They were shocked. Most people thought the new work was a joke. "This is small children's work!" they said. "Where is your own?" Emily never took criticism lightly and now, although the newspapers gave haltingly positive reviews, she remembered only the negative responses.

To Emily, the new work was brighter, cleaner, simpler, more intense. It had all the "bigger, freer seeing" she had been striving for. But the public thought it outlandish. Her paintings were insulted and jeered at. Her friends, when they came to visit, didn't mention painting and averted their eyes from her walls.

Emily had a habit of hovering at her own exhibits in hopes of overhearing people's spontaneous comments. When her pictures were hung at an exhibition of The Fine Arts Society, she heard people laugh at her work. She said, "It could not have hurt me more had they thrown stones."

The schools where she had taught children refused to hire her back. A few of her old pupils came for lessons, but Emily feared it was strictly out of pity for her and "their money burnt me."

She refused to be ashamed of her new work. She knew the humiliating silence from her family and the jokes were a result of the conservatism of western

Canada. She clung to her belief that her new ways of painting suited this new country. As she saw it, she had "broken loose from the old photographic, pretty-picture work" of docile cows beside placid rivers. That had to be left behind if she was ever to capture the wildness of her beloved British Columbia.

In spite of the less than enthusiastic response to her new work, she was eager to return to the totem poles. In 1912 she launched the most ambitious of all her sketching trips to date – a six-week visit to coastal and central northern British Columbia, including Alert Bay, the Skeena River Valley, Kispiox, and the Queen Charlotte Islands, now known as Haida Gwaii. She did dozens of drawings and paintings. As she did so, she realized she was holding back some of the more "modern" aspects of the "bigger, freer work" she had learned in France. Instead, she was "working for history," in a photographic manner, to record what she considered the treasures of a dying culture.

It was the first time she had spent such an extended period of time in B.C.'s forests and the first time she met D'Sonoqua.

On Haida Gwaii she made friends with Clara and William Russ, a Haida couple from Skidegate, who were patient, attentive guides. They took her to villages where she wanted to sketch, put up tents for her when it rained, cleared bush from the base of totem poles so she could paint them properly, and once caught a "devil fish" to give some variety to the canned rations she'd brought along.

One night they arrived at Tanu off the southern end of Haida Gwaii. William moored his gas boat at what Emily thought was a long distance from land. Then he paddled Emily and her small escort (a girl) and her dog to shore in his canoe. (Local missionaries usually insisted Emily take their daughters along to avoid the "scandal" of being an unescorted woman.) When William went back for the others, Emily and the girl were alone. "It was so still and solemn on the beach, it would have seemed irreverent to speak aloud," she said later. There is a particular, overpowering silence in these islands, as if everything "were waiting and holding its breath." Even her dog felt the power of the place for "he stood with cocked ears, trembling."

At one side of the beach was a bluff the Russes said was haunted. Facing the water were the remains of the great houses where several families once lived, and several totem poles, one of which had belonged to Clara's grandmother. Emily knew that, because she was non-native, what she saw in these villages "must have been quite different" from what native people saw.

The Russes helped her by telling her about their stories as they sat around the fire: how the hat on the figure at the base of this pole, for example, was a hat of honour. Clara told how the man wearing the hat once adopted a raven for his son. But the raven was a trickster who caused a flood to be brought down on his foster parents, and the family was only saved by climbing up on the rings of the hat of honour.

When it was time for bed, Emily was alarmed to see the Russes carry their canoe toward the water.

"What are you going out to the boat for?"

"We are going to sleep out there."

"You are going to leave us alone in Tanu?"

"You can call if anything is wrong," they told her.

But Emily knew the boat was too far out for them to hear her if she called. She watched the canoe slip into the blackness, and all that night, with the story of the trickster ringing in her ears, she slept with the tent flaps open. She felt safer when the trees were close.

The next morning she got to work early. When it was time for breakfast, there was still no sign of life on the big boat. It got late. Suddenly Emily remembered something she'd heard in the last village.

"Do you remember what they said about those Indians being asphyxiated by the fumes from their engine while they slept?" she asked the girl.

"I was thinking of that too," the child replied, and suddenly they both yelled louder and ran as far out onto the point as they could to get closer to the bobbing, empty-looking boat. "There was a horrible feeling down inside us," Emily said, "that neither of us cared to speak about." Finally a head peered up over the side, and the woman and girl on shore were greatly relieved.

On this ambitious trip, Emily found native people who welcomed and helped her, like the Russes, and others who ordered her to leave their village. She encouraged the people who wanted to watch her draw, often giving them a sketch, and when she left an inhabited village, she gave a small exhibition of what she had done there.

She found some villages abandoned, like Tanu, and others with brass bands and street lamps. She

camped on beaches and slept in missionary beds, broke through thick salal and nettles, fended off hordes of slugs and mosquitoes, and everywhere, she sketched the poles.

It is unlikely any European woman before Emily Carr had accomplished such a trip alone. (European women in the northwest were mostly wives of missionaries and pioneers.) In overcoming the hardships, dangers, and fears of the journey and returning triumphantly with a large number of sketches and drawings, she must have had some sense of a quest complete.

Emily's hope now was that the provincial government would buy her entire collection of over two hundred northern paintings to hang in the parliament buildings in Victoria. To this end, the minister of education contacted Dr. C.F. Newcombe, an ethnologist for the provincial government. Would he please visit Miss Emily Carr to assess her work for its anthropological value?

Dr. Newcombe liked Emily and bought three of her paintings for himself, but after his visit to her Vancouver studio he reported to the minister that although her sketches were accurate, he found the colours too bright. Also, in her efforts to get the entire pole into her pictures, she sometimes distorted perspective. He suggested that Miss Carr be hired to paint decorative scenes on the walls of public buildings. The government, now restrained by a growing economic depression, refused to buy her work.

This rejection must have hurt Emily. If she could not make a living selling her art, she would have to find another way. She returned to Victoria, where, with the money her father left her, she built a small boarding house at 646 Simcoe Street in what had once been the cow yard of her family property. At the age of forty-two, she became a landlady.

∽

The house was called Hill House, but when Emily wrote about it years later, she called it The House of All Sorts because of the many different kinds of people who passed through. It had two suites on the bottom floor and a larger one, including a splendid painting studio for herself, on the top floor.

It was a good idea – keeping a boarding house was considered an appropriate job for a woman – but it was bad timing. In 1913 there was a worldwide depression that would soon culminate in World War I. There were fewer and fewer people who wanted to rent houses and many families trying to survive on a soldier's low wages.

Emily's original plan had been to have a handy-man or maid to help her with the work so she could paint part-time. But as World War I closed in and rents fell, she could barely afford to pay the mortgage let alone hire help, and she was forced to do most of the work herself. For extra income she also had to turn part of her own flat into a tiny additional apartment she called The Doll's House.

Emily loathed landladying. The work was endless. In winter she woke up before dawn and eased her way

down the wet or snowy outside steps to light the coal furnace in the basement. In summer she cut the grass, kept large fruit, vegetable, and flower gardens, and always, she cooked, cleaned, repaired, and painted apartments as tenants came and went.

It wasn't the work that bothered her. She was rather proud of the fact that she kept such a neat establishment. But *The House of All Sorts*, the book she later wrote about the experience, is full of anger. Dealing with her tenants was a torment because it constantly drew her away from her own work. She felt not just tied, not just nailed, but screwed down, twist by twist, to the house and its unending stream of crabby, demanding, noisy, endlessly demanding tenants. They seemed to say to her, "Forget you ever wanted to be an artist. Nobody wanted your art. Buckle down to being a landlady."

Her first tenants were newlyweds fresh from their honeymoon. The bride slip-slopped all day around the apartment in her slippers and negligee. When she occasionally did a washing, she embarrassed Emily by leaving it, shamefully grey, hanging for days on the clothesline until Emily furiously pulled it down herself. The couple left abruptly when their brand-new furniture was reclaimed because they hadn't kept up the payments. Their parting gift was a pot of soup thrown down the kitchen sink that required that Emily become a plumber because she couldn't afford to hire one.

When Emily consulted a more experienced land-lady about the whole affair, the woman explained, "In time you will learn to make yourself hard, hard!"

∽

Emily took everything personally, She was scandalized when her tenants did things like hang their woollen underwear and peach scanties out their (her!) front window to dry, for all of Simcoe Street to see.

She was embarrassed at having to negotiate and take money from tenants, angry when they rearranged or complained about the furniture she carefully bought and placed in each apartment. She resented their demands to pay a few pennies less rent and their insistence on gossiping to her about the other tenants.

In those days, builders didn't know much about soundproofing, so she also had to deal with complaints about noise, especially from amateur musicians. It was agony for her to be "tough" in these situations.

One of the musicians was a sweet young girl whose commitment required piano practice from 7:00 a.m. to 10:00 p.m., immediately under Emily's studio. Emily felt as if "each note might have been pounded on my vertebrae."

Without letting go of the piano, the child then took up the violin. Now "squealing wails" were added to the tumult of endless piano scales. Emily agreed with the other tenants that "something must be done" but she was loathe to be the one to do it. The child was sweet. Her parents were lovely people. The noise was unbearable. Emily went.

There was the child seated at the piano not looking at all "strong, wicked or big enough to torture a whole household." Emily chatted. She talked of everything except pianos and violins. Then she sneaked back to her studio, trying not to catch the other tenants' eyes, and started to paint.

"Wail, wail, wail! Every wail wound me tighter," she wrote. "I was an eight-day clock, overwound, taut – the key would not give another turn!"

Down she went again. This time both parents were home and Mother was surprised at such a quick repeat visit.

Emily stammered, "Other tenants…object…"

Papa and Mama exchanged nods.

"Perhaps the violin practice could be arranged for where she learns."

"Impossible," said Mama.

"At the home of one of her aunts, then?"

"Both live in apartments where musical instruments are not tolerated!"

"The Park bandstand," groaned Papa with a nervous glance towards Mama. "I suggest the Park bandstand."

The little girl rushed from the room crying.

"I fear we must look for a house," said Mama.

"An isolated house," groaned Papa.

And Emily retreated to the sounds of the little girl's sobs.

☙

She was not beyond physical violence when things got too much for her frayed temper. Take for example the

widow who crammed her three-room apartment with a yellow-haired son and twelve rooms' worth of cheap, glossy furniture with only a narrow alleyway to let visitors squeeze through.

When the widow would neither pay her rent nor leave, Emily seized a basket full of her pots and pans from the back step as a form of payment. When the widow followed her upstairs, "screeching," Emily, pushed to the limits of her temper, retorted, "Take it then – this too,'" and from a higher step, plopped one of the dirty zinc pails over the widow's head so that the woman retreated, wobbling, with her arms full of basket and her head encased in a helmet of dirty zinc. The widow and her yellow-haired son left shortly after.

<center>◌◍</center>

Emily seems to have kept her apartments none too warm in winter, for coal cost money. Once when she caught a male tenant sneaking extra coal into the furnace, there was a scuffle. Emily says he hit her. Other tenants cheered. One tenant said she pushed him into the coal bin and trod on his glasses. Another time she turned the hose on a tenant.

Events like these made her feel like "a hen under whose wing hornets had built their nest and stung me every time I quivered a feather." When she grew really, really angry with her tenants, she turned off the water, pulled the fuses from the electrical box, and went upstairs to hide in her attic room, leaving them waterless and in the dark.

The attic room that was Emily's "special corner" and hiding place lay at the top of a narrow staircase in one corner of the studio. On its small entrance door she painted an Indian-style bear totem and on the underside of the roof, right on the cedar shingles, two huge eagles – also in the Indian tradition. Their spread wings covered the entire ceiling and hovered a few feet above her head as she slept. Emily loved these two great symbols. They made, she said, "'strong talk' for me."

∞

Money was constantly a worry. She sold the produce from her garden, raised chickens and rabbits, and made hooked rugs. In about 1924, she began producing pottery. One of her tenants asked her to make "Indian pottery" she could sell in a gift shop that she operated in Banff in the summer.

Emily got out the old wicker pram she used to help carry things (the same way we now use grocery store buggies) and wheeled it to the Dallas Road cliffs or to local construction sites. There she dug out the local blue clay and wheeled it home. Then she shaped it into small objects such as bowls, candlesticks, ashtrays, miniature totem poles, and plates: "stupid objects," she called them, "the kind that tourists pick up."

With the help of her chimney sweep, she built a rough brick kiln in her back yard. Firing the kiln was a twelve- to fourteen-hour ordeal that required her to stand constant guard with the garden hose to keep the

roof soaked. Once the roof caught fire and another time, the floor.

She decorated her pottery with Indian-style designs. She felt guilty using those beautiful designs on material for which it was not intended, but she knew it was why the tourists bought her pots. As she said, "I hated myself for prostituting Indian art; our Indians did not 'pot', their designs were not intended to ornament clay – but I did keep the Indian design pure."

Other potters, however, seeing how well her work sold, copied her designs, but badly, because they didn't understand or care that they were misusing them.

Over several years, Emily produced hundreds of these small objects to eke out her poor income. As she said, "Clay and bobtails paid my taxes – clay and bobtails freed me from the torture of landladying." It was the bobtails that gave her joy.

When her English bobtail sheepdog named Billie died, Emily decided to start a bobtail kennel. The breed was known for being strong, hard-working, and excellent companions, and there weren't many in Canada. Soon, it was one of her few great pleasures to open the gate early each morning to release the dogs, then pant along behind them as they burst from the yard and raced across the park to the top of Beacon Hill. On top of the hill there was a moment of peace as all of them rested and Emily watched the new dawn. Then they returned to the responsibilities of the boarding house.

As a landlady who could rarely afford to hire help, Emily frequently picked up the tools herself. She built her own painting easels and her own wooden stretchers

to prepare canvases to paint on. Once, when she ran out of wood to make her own picture frames, someone saw her pull the pickets off her garden fence. She fixed plumbing, did repairs, and regularly calcimined, or whitewashed, dirty walls to keep them sparkling and sweet smelling.

She also built the dog kennel at the foot of her garden. For the little ones, she set up a puppy room in the warm basement with a cot nearby so she could be close when a dog gave birth, or was sick. On occasion there were up to thirty pups at a time in the puppy room. If a mother had more than six (and nine was considered an ordinary litter), Emily would help by feeding the babies three times a day for three weeks with a feeding bottle.

∽

The kennel was hard work, and sometimes it was heart-breaking. Once, an epidemic of distemper broke out. So many of her dogs died that she had no more room in the back yard to bury them. Emily was forced to put their limp bodies into weighted sacks and carry them to the Dallas Road cliffs where, at high tide, after dark, she threw them to the sea.

The sight of this elderly, heavyset woman in her hair net and home-made dresses, throwing sacks of dead puppies over the Dallas Road cliffs, surely did nothing for her growing reputation as an eccentric.

She used her wicker pram to bring home bones and scraps from the butcher for a nourishing stew for her animals, and once, her load included half a pig's

head. "There was something sinister in that pig's one eye," she remembered later.

The meat, it turned out, was bad; not bad enough to hurt the adult dogs, but the next morning one female's new litter were all ailing and one pup had already died. For the next several days and nights Emily sat up, spooning milk and brandy down puppy throats. The runt had the toughest time; for days he writhed from one convulsion to the next, and one day, just before dawn, Emily found him stiff, his tongue lolling, eyes glazed.

Too exhausted to dig a grave, she hopelessly poured another trickle of brandy down his throat and, leaving the feeding bottle on the floor where it lay, went back to her cot for a few more hours of sleep. In the morning when the sun woke her, the runt was on the floor in a patch of sunshine, sucking at the feeding bottle between his paws. She named him Grits.

By now, Emily's reputation as an eccentric was in full bloom. For years she had been known as "hard to get along with." Now she had adopted those wild colours in her paintings and further shocked the good people of Victoria by smoking, swearing, and playing cards. Added to that were her looks – a short, chubby woman who always wore shapeless black smocks she sewed for herself, each exactly like the others, with no shred of attempt at fashion, design, or decoration. On her feet she wore sturdy laced shoes or –for rough walking – a pair of old boots. From the 1920s on she wore on her

head a hairnet with a velvet band. No one knows exactly why. Maybe it was just to keep the hair out of her eyes.

She seldom went anywhere without animals: some combination of dogs, rats, cockatoos, parrots, cats, and later a monkey, attached to her waist by a chain. When she pushed her highly sensible wicker pram down the street to carry her groceries, people crossed the street to avoid her. "There's the woman who travels alone to the forest, who lives with Indians and paints totem poles in wild colours," they might be saying. "There's the landlady with the terrible temper, the one who keeps a rat and a monkey for pets."

In 1921 Emily had traded a bobtail puppy and thirty-five dollars for a Javanese monkey she called Woo. Things got livelier around the House of All Sorts as Woo, clad in the bright dresses Emily sewed to keep her warm, ate whatever came to hand, including soap and tubes of artist's paint. In the shed where she slept in summer she tore shingles off the roof, smashed the window with her drinking cup, tore up floorboards in the search for tasty bugs, and allowed no animal except her favourite dog, Ginger Pop, and no human except Emily, to enter. Whether they liked her or not, everyone was fascinated by Woo.

Next to Emily, Woo adored Alice, who always kept a treat for her – grapes, cherries, or a candy. Only once was Woo angry at Alice. Alice was busy in her crowded kitchen, surrounded by a confusion of children, when she accidentally stepped on Woo's tail. Furious, Woo squealed and grabbed the strings of Alice's apron and tugged hard, hoping they were as sensitive as her own tail.

☙

As it got harder to rent suites, Emily had less and less time to paint. At one point, things got so bad that she was forced to rent her own suite and live in a tent in the back garden, cooking in a lean-to. Another time, her studio became a dining room for boarders.

Her house was built to contain, she said, "the finest studio in the town." But for many years the studio of which she was so proud was "a torment" for her to work in – when she could work in it at all – because it was so public. The only way to her flat was through the studio where canvases in progress stood on two home-made bench-easels that she instantly covered in dust sheets if anyone came. If a tenant tapped at her door while she was painting, she felt caught, "exposed and embarrassed as if I had been discovered in my bathtub!"

To save space, Emily had suspended her chairs from the high studio ceiling with a pulley system she rigged up herself. If a welcome visitor came, she lowered a chair; otherwise, the furniture stayed overhead. Time was precious. If she had tedious guests, she might also "put the clock on a little" to speed their departing.

But in fact, for the next fifteen years Emily's studio was rarely used for art. She felt isolated from the artistic community of British Columbia and "heavy in spirit" because they had ridiculed and refused to buy her work. She gave up hoping for their approval. Painting had given her so few rewards. Now she would be a good landlady – even if she hated it. She would show the world that she could do *something* right.

Emily once talked about how satisfying it could be to "clean perfectly, to shine and polish and *know* that it could not be done better. In painting that never occurs." There is an absolute certainty to cleaning – a certain satisfaction in knowing, all by yourself without anyone else's judgment, whether it is done "right" or not – and Emily grasped at it. Besides, the life of a struggling landlady kept her so busy, she told herself, she had no time for art, anyway.

One consolation was the friendship of a child named Carol Dennise Williams, whom she met in the early 1920s. Emily regularly went for lunch to Alice's school and they probably met there, when Carol was a student. To Emily's amazement, the child defended her against her sisters' criticisms. They liked each other instantly and began spending long periods of time together. They had much in common, including a love for animals and painting. Emily taught Carol everything she knew about dogs, and they frequently painted together and went on sketching trips around the city.

In the girl's presence Emily returned to a world of fantasy and play, and all the warmth that until now had been reserved for her animals was showered on Carol. Emily liked Carol so much that she asked her mother if she could adopt her. Mrs. Williams said no, but she agreed to let Carol call Emily "Mom," and Emily gave Carol the pet name, "Baboo." In 1926 Carol moved to Toronto, where she eventually married and became Carol Pearson, but their friendship continued – with letters, visits, and Mother's Day flowers – until Emily's death.

∞

Mostly, the years as a landlady were a time of withering for Emily. When the boarding house was originally built, there were four large maple trees on the lot. The two where the house would be built were cut to three-foot stumps. One of these immediately died and the second was isolated in a dark part of the basement. It had no air and only one small window in a far corner for light. But that maple tree would not die.

Emily described how "robbed of moisture, light and air, the maple still remembered spring and pushed watery sap along her pale sprouts, which came limper and limper each year until they were hardly able to support the weight of a ghastly droop of leaves having little more substance than cobwebs. But the old maple stump would not give up."

Like Emily. Given little nourishment by her family or artistic community and barely ahead of the debt collector, she still had some small instinct for art that struggled to stay alive within her.

Emily liked to say that for the fifteen years she was active as a landlady, she never painted at all, but this is an exaggeration. Although she was discouraged, she managed to do some painting during this time. A few people, like Marius Barbeau, an anthropologist who studied B.C. native cultures for the federal government, and H. Mortimer Lamb, an important art collector in Vancouver, saw and appreciated the value of her work. Emily also continued to go on sketching trips, although they were closer to home than the ambitious trips of earlier years. She exhibited some

paintings and made connection with several Seattle artists whom she could talk to about painting and art. But mostly, like the maple tree in her basement, she just hung on.

Now, all that was about to change.

8

Breakthrough

> They had torn me; they had waked something in me that I had thought quite killed, the passionate desire to express some attribute of Canada.
> – Emily Carr, *Growing Pains*

I n August 1927 Emily received a phone call from a man who introduced himself as simply, "Eric Brown, Canadian National Gallery." He wanted to speak to Miss Emily Carr about her Indian pictures. Emily was suspicious. Later she said she didn't even know Canada had a national art gallery. Grudgingly she agreed that he and his wife could come to her studio to see the

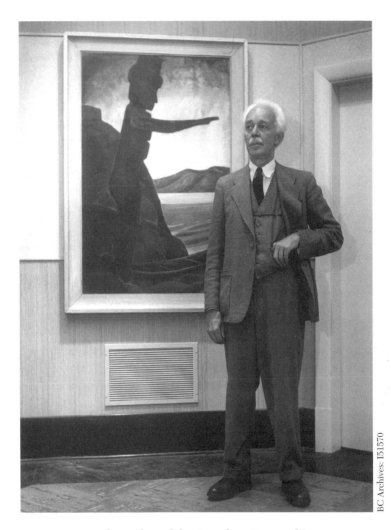

Artist and member of the Canadian Group of Seven,
Lawren Harris, in front of Emily's painting,
Silhouette No. 2. The night she met Harris she wrote,
"Something has spoken to the very soul of me."

pictures on her walls, but while he talked, she sullenly eyed the lump of clay she had been working on.

As he looked at her paintings, Mr. Brown mentioned a new group of painters in Toronto who called themselves the Group of Seven. They were working like her, he said, in the modern, abstract style. Emily had never heard of them, but her ears perked up. A man named Fred Housser, Brown continued, had just written a book about the Group called, *A Canadian Art Movement*.

Then Eric Brown asked if he could have fifty of Emily's pictures for an exhibition of West Coast art on native themes that he was planning for the National Gallery that winter.

Emily was dazed.

"Who did you say you were?"

Brown laughed. "Artists this side of the Rockies don't keep up with art movements, do they?" he said. "Where did you study?"

"London, Paris, but I am not an artist any more."

As soon as he left, Emily rushed downtown to buy Housser's book. Reading it, she could see that, like her, the Group of Seven were trying to free themselves of old European traditions, to develop a uniquely Canadian art nourished directly by Canadian soil. Instead of sitting in stuffy rooms or copying from photographs, they were actively out in the wilderness – mostly in northern Ontario but sometimes as far west as the coast – to camp and sketch, just as Emily had done.

She was moved by their story and sympathized with the fact that they, too, had suffered harsh criticisms. But

when she saw the pictures in the book, especially of Lawren Harris's painting, *Above Lake Superior*, she knew she had to meet these men.

Emily's sisters told her to go; they would look after the boarding house and the animals. Emily wrote to Brown, "I can come," and shipped off twenty-seven watercolours and eleven oil paintings along with several hooked rugs and pottery pieces. Brown, Director of the National Gallery, had promised that if she came, he would give her a free railway pass that would let her stop in Toronto to meet the Group of Seven before she came to Ottawa.

∽

In Toronto, everyone was kind, though they hadn't yet seen her work, and the Women's Art Association showed her around to the studios of the various members of the Group, beginning with A.Y. Jackson.

Emily felt an immediate kinship, although, looking at Jackson's paintings of native subjects, she felt "a little as if beaten at my own game." His work seemed to have a rhythm that hers lacked. "Mine are so downright," she mourned. Until now, her major effort had been to paint the totem poles, and she had been careful to be exact in reproducing them. But the historical record she made and offered to the public had been rejected. Now she was free to respond more personally to the totem poles. Next time she painted them, she promised herself, she would let go and paint from her heart.

"I'm going off on a tangent tear," she said. "There is something bigger than fact: the underlying spirit, all

it stands for, the mood, the vastness, the wildness…, the eternal big spaceness of it. Oh the West! I'm of it and I love it."

Then she visited the studios of Arthur Lismer, whose paintings gave her a feeling of "exhilaration and joy." Technically, she felt the Group's work was better than hers. "I'm way behind them in drawing," she wrote "and in composition and rhythm and planes, but I know inside me what they're after and I feel that perhaps, given a chance, I could get it too."

Emily wondered if these men felt the common chord she felt between them and her. "No," she told herself, "I don't believe they feel so toward a woman." But oh, how she yearned!

There were no women members of the Group of Seven, and Emily was one of what was still a tiny group of serious women painters in Canada. In the 1920s everyone assumed that to be an artist, you had to be a man, just as we used to think that to be a carpenter, you had to be a man, or to be a nurse, you had to be a woman.

Women artists were not taken seriously because "everyone knew" women couldn't paint. The mere fact that they were women blinded almost everyone – women and men alike – to their skill. The result was that women's art was rarely displayed or bought, so that a woman like Emily could hardly make a living by her art.

This was discouraging enough, but there was something equally hard; when everyone says you can't do something, it's amazing how much you start to believe them, even if you don't want to. Stubborn,

rebellious Emily had fought to prove that a woman could be a good artist, but the public and her own family and many of her teachers, including Olsson in England and Gibb in France, reminded her that she was "only" an exception to the rule – until she almost believed them.

Emily had also fought a lonely battle with the other painters in Victoria over the importance of abstract art. Most of them laughed at her "modern" designs and colours.

Now suddenly she had met a whole group of men, the Group of Seven, who seemed to agree with her, who felt as she did about art, and about Canada, and she desperately hoped she could fit in with them, "put in a little spoke for the West, one woman holding up my end."

She was overwhelmed by the Group's energy and enthusiasm, by their strong support of each other in the face of all opposition. They were "big and courageous," she thought, where she – busy running a boarding house instead of painting – had become a "quitter." She didn't talk about the fact that the men in the Group were able to sell their paintings to support themselves or that Lawren Harris, their leader, was the son of wealthy Thomas Harris of the Massey-Harris Company that manufactured farm machinery.

It was Lawren Harris's work that moved her most. When she visited his studio he brought out painting after painting for her to look at. Emily was struck dumb by the strong feeling of spirituality in his work, the sense that he had not only found what she called "God" in the wilderness but that he had been able to

translate that feeling into pictures. As Harris continued to show her his work, he paid her the highest compliment one artist can give another: he invited her to criticize it.

"If you see anything you can suggest," he said, "just mention it, will you?" Emily was deeply moved.

"Me? I know nothing," she said.

"You are one of us," was his reply.

That night she lay awake crying and writing in her journal, "Oh, God, what have I seen? Where have I been? Something has spoken to the very soul of me, wonderful, mighty, not of this world....Something has called out of somewhere. Something in me is trying to answer."

Lawren Harris invited her to visit his studio again on her way home, and Emily could hardly wait to take him up on it, but first there was the Exhibition at the National Gallery in Ottawa that she had come for in the first place. In Ottawa she stayed with Marius Barbeau and his family. They arrived together for the opening.

It was, Emily reported, horrid. Usually two thousand people were invited to the opening of a new exhibition, but for this one, Eric Brown only sent invitations to a few artists and the people who worked in the building. He wanted it to be informal, he said. The exhibition was entitled "Canadian West Coast Art Native and Modern," and the majority of the exhibits were Emily's. When people said nice things about her work, she could hardly believe them. Compared to the

native work and the Group's paintings, she thought, her landscapes looked stiff and her colours garish. But she had to admit to her journal that perhaps her work had one thing the Group's lacked, particularly when they painted the West, and that was "the love in them of the people and the country" that hers had. "It was my own country," she wrote, "part of the West and me." She was beginning to see that perhaps she did, indeed, have something special to offer; that her vision and experience of western Canada were unique.

∽

On her way home, Emily again stopped in Toronto to visit Harris. She was very nervous. What right had she to take up this busy man's time? But her need to talk to him and especially, to see again his painting, *Above Lake Superior*, overcame her fears.

When she phoned, Harris not only invited her to his studio the next day, but he invited her to dinner that night. He showed her more paintings, and with his wife, they listened to a symphony on his gramophone. Emily had felt what she called the "holiness" in his work, and now she said, "to sit in front of those pictures and hear that music was just about heaven."

The next day, December 13, was coincidentally – her birthday, and it made "a splendid birthday." But it was more than that. Later Emily would say "that long talk in Lawren Harris's studio was the pivot on which turned my entire life."

They talked about the craft of painting. Harris showed her some of the techniques he used, like rub-

bing raw linseed oil into the canvas before he painted, to make the colours brighter. He also told her more about the Group's ideals and their goal of developing a distinctively Canadian art, not through schools or tradition but out of the land itself, by direct contact with nature.

Most importantly, Harris talked about his spiritual beliefs, especially about theosophy. Theosophy is a religious belief that rejects traditional Christian belief in the divinity of Christ or the power of prayer. It comes from a mix of Eastern and Western religious philosophies and holds that the world is a part of God and that God – the divine – can be directly known through nature. As a theosophist, Harris believed that art was not just an intellectual exercise, but an emotional, intuitive response to the divine spirit in nature.

Emily was electrified. Although she was always deeply spiritual, she hadn't been able to bear the snooty hypocrisy she often saw in the church, and she hadn't attended regularly since she had come home from England. It wasn't in church that she felt closest to the divine but outside, in her beloved northwest. She knew that Harris's work had something hers lacked, something she had been searching for. Talking with him made her wonder if perhaps she too might find in nature the God she'd "longed and hunted for and failed to find," the one Harris had found.

From her youth on, she had had a vague desire to create an art unique to the Canadian northwest, but she was never sure exactly how to go about it. Now she had permission to try. Someone was encouraging her to explore the spiritual aspects of the West Coast landscape.

Harris said, "I understand you have not painted for some time?"

"No."

"Are you going to now?"

"Yes."

Emily was no longer alone. She knew how far she had to go but finally she had a glimpse of where that place might be. She was on fire to get home and paint.

Before she left, Harris gave her a list of books she could read. "You are isolated out there," he said. "Keep in touch with us." And he told her that as soon as he saw her paintings, he would write.

∽

On the long train ride back across Canada, Emily worried. Did being a landlady make her small and bitter, incapable of great art? What would the Group, especially Harris, think of her work when the Ottawa show came to Toronto? Was it good enough? Would they like it? And she was old – almost fifty-six years old. Was it too late? Or was it maybe possible that, if she worked very hard, her art might get better so even her sisters would think it wasn't one big waste of time?

Back in Victoria, she impatiently dealt with chores and sick dogs and Christmas parcels and cleaning. Then, finally, she brought out some of the early Indian pictures and began to paint.

A letter arrived from Toronto. In it, Lawren Harris wrote, "The exhibition of West Coast Art is at the Gallery. As interesting a show as we have had in the Gallery. Your work is impressive, more so than Lismer

had led me to believe, though he was genuinely moved by it in Ottawa. I really have, nor can have, nothing to say by way of criticism....The pictures are works of art in their own right...have creative life in them...they breathe."

Emily was thrilled. From now on, her job as a landlady would take second place. To heck with cleaning. She hauled out her sketch sack, called her dogs, and headed into the woods again, an artist, "singing."

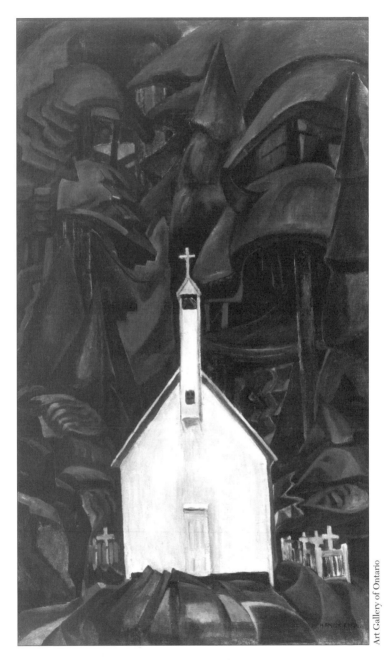

Indian Church by Emily Carr, 1929.
Lawren Harris bought this painting and hung it in his house.

9

Finding Forest

Dear Mother Earth! I think I have always
specially belonged to you.
– Emily Carr, *Hundreds and Thousands*

Emily began to exchange regular letters with
Lawren Harris. With him, she could be entirely
open in talking about art.

Harris found her sketches "vigorous, alive, creative"
and urged her to "keep at it." (This was particularly gen-
erous of him given that, by 1932, he himself had almost
stopped painting.) He told her that her paintings were
unique in Canada. "Their spirit, feeling, design, han-
dling, is different and tremendously expressive of the

British Columbia Coast – its spirit," he wrote, "perhaps far more than you realize...." And he urged her not to let feelings of isolation or depression slow her down. "In despair again?" he replied to one of her letters. "Every creative individual despairs....No matter how fine the things are, there are always finer things to be done...Keep on working, change your approach, perhaps, but don't change your attitude."

Back in British Columbia, Emily was excited to be working with the northern sketches again but she needed new material. In 1928 she scraped together enough money for another trip to northern Vancouver Island, the Skeena and Nass Valleys, and Haida Gwaii. By this time she had changed from raising English bobtails in her kennel to raising smaller griffon dogs. One of her favourites, Ginger Pop, came with her.

It was a rough journey. It rained almost unceasingly, and when it stopped raining, the mosquitoes came out. Emily spent long periods of time waiting for transportation to the next village, wearing her mosquito armour: a long dress, thick canvas pantaloons on her legs, two pairs of gloves, and a cheesecloth veil over her head with a pane of glass inserted for her to see through.

On this trip, lots went wrong. Weather on Haida Gwaii, for example, was so bad that she couldn't sketch any of the villages she'd hoped for, but she was undaunted and managed to reach enough villages, including Kitwancool and Greenville, to make several new sketches and consider her trip a success.

When she returned to Victoria, a young Seattle artist asked if she could gather a class in Victoria for

him to teach. His name was Mark Tobey. He was an excellent teacher and his lessons had a great impact on her. Emily grumbled that his theories all sounded rather like "painting to recipe," but it was from Tobey she learned that "Nothing stands alone; each is only a part. A picture must be a portrayal of relationships."

Like Emily, Tobey was deeply interested in Northwest Coast native art. Many of the principles he taught her, she had already seen in the totem poles; for example, although almost all poles were true to the shape of the tree, the carver seemed to manage the illusion of even greater height and diameter. Totem poles also appeared to hold a sense of drama and inner tension so the carved figures seemed to press out against the surface. Emily applied this lesson to her recent paintings, including *Totem Mother* from Kitwancool. She was beginning to show objects not merely sitting in a landscape, but shining, as if with some power or light, from inside.

In 1929 Lawren Harris suggested that Emily stop working from native material and go directly to the forest for her inspiration. "For a little while at least," he wrote, "give up Indian motifs. Perhaps you have become too dependent on them; create forms for yourself, direct from nature." And in fact Emily admitted later that "while working on the Indian stuff I felt a little that I was but copying the Indian idiom instead of expressing my own findings."

Perhaps in those early days when Emily felt isolated and uncertain of her right as a woman to paint, painting the totem poles helped justify her commitment to art. From the time she first saw the standing

poles in Sitka in 1907, she knew, instinctively, that First Nations carving and design were important. If people said she had no right as a woman to paint what she wanted, maybe she could justify her art by saying, "It's not for me. It's for the poles."

Harris was encouraging her – clearly giving her permission – to step out and paint from her own core. The poles had been precious teachers to Emily, but now, forest itself began to move to the foreground for her. "I learned a lot from the Indians," she said, "but who except Canada herself could help me comprehend her great woods and spaces?" By 1930 the D'Sonoqua she painted from Koskimo village was barely visible amidst green growth, almost smothered by the dense foliage.

∽

In the spring of 1929 Emily took a train north, then west on Vancouver Island to Port Alberni, where she boarded a steamer north to Nootka Island. One of the sketches she did here was of a one-room native church. Back in Victoria she changed its environment a little: she painted white crosses around the church as if it were surrounded by a graveyard. She ignored the other buildings that were there in order to emphasize the isolation of the church, alone against the sweep of tall trees. She added a breath of danger. In the final painting, *Indian Church*, dark slices of undergrowth rush like green waves up to the front door of the small, white church. And yet it stands, holding its cross like a wobbling Christian soldier, almost burning with a clear

interior light –a Lawren Harris light – against the green waves that threaten to drown it.

By simplifying – almost carving – the forms of trees, by immersing herself in the power symbolized by both church and forest, Emily was beginning to portray the inner spirit she sought. Perhaps it is no coincidence this painting was bought by Lawren Harris, who praised it lavishly, saying Emily would probably never do better. He said it so often that she finally got mad at him, saying she certainly *would* do even better paintings in future!

∽

Like most Europeans, Emily had a difficult relationship with forest. Once she stepped past the edge and moved into its dark interior, it frightened her. Although she was born in British Columbia and loved forest, it was – it is still – wild, foreign ground. There are no trodden paths except those travelled by animals. On the coast in particular, the light is often dim and diffuse – as if things are seen in a dream. Sound is different, too. On windy days, trees creak and roar as loud as any ocean surf. There are infinite small sounds – tiny scuttle of beetles, harsh call of a crow or eagle, drip of rain – all set like minute lights against the backdrop of such a profound, dark silence that every crackle of underbrush, each snap of a twig, is magnified. In dense forest, there is the sense of something alive – something invisible – a pulse beneath one's feet. Emily was often afraid.

Yet she loved trees better than people. "It is funny," she said later, "how I sought my companionship

out in woods and trees rather than in persons. It was as if they had hit and hurt me and made me mad, and cut me off, so that I went howling back like a smacked child to Mother Nature."

She came seeking sanctuary, but it was a foreign church. Trees, like drapery, hung low. If she screamed, no one would hear. The ground was often overgrown with head-high bracken and sharp underbrush so she couldn't pass. Holes, rocks, tree roots all lay half-hidden to slow her heavy progress with camp stool and sketch sack as she looked for a clearing, a place to sit and work. The smell was of growth, decay, and rich, wet humus.

In working on the painting of D'Sonoqua called *Strangled by Growth*, she sought to portray the dark side of this forest. It was a picture, she said, of "ferocious, strangled lonesomeness...creepy, nervy, forsaken, dank, dirty, dilapidated, the rank smell of nettles and rotting wood, the lush greens of the rank sea grass and the overgrown bushes, and the great dense forest behind full of unseen things and great silence."

Emily continued to go to the forest because she felt there the "holiness" she had seen in Lawren Harris's work; material objects – trees, undergrowth – held the spiritual. "Reverence the container," she said, "as you reverence a church." And yet it was frightening. "Should you sit down, the great, dry, green sea would sweep over and engulf you," she wrote. "If you called out, a thousand echoes would mock back."

In works such as *Strangled by Growth*, that vague sense of being watched, and the sometime feeling of dread and fear that goes with it, became a part of her

art. "You've got to have the 'creeps'," Emily said, and though fear is not a dominant theme, the balance between terror and affirmation – joy, even – is a large part of the power in many of her paintings.

∞

Several things gave her courage. One was that, even as a child, she had always felt more at home in the woods than in downtown streets. "I must be very animal and earthy," she once wrote, "because I love the earth; it's so dependable. I can't trust machines."

Her respect for the totem poles gave her courage, as did the fact that she now carried a small journal in her sketch sack. Writing her thoughts to Harris had so helped her to clarify them that she got into the habit of writing before she painted.

"Trying to find equivalents for things in words helps me find equivalents in painting," she said. Now, before she started a new piece of work, she asked herself, "What attracted you to this particular subject? Why do you want to paint it? What is its core, the thing you are trying to express?" Then, in the fewest words possible, she wrote the answers in her little book. She found this method "very helpful."

Emily's courage was also no doubt bolstered by the creatures who accompanied her into the woods: dogs, birds, monkey, and often, when no one else could be persuaded to mind her, the white rat Susie, tucked inside a cut-down rolled oats carton. Animals, Emily said, "seemed somehow to bridge that gap between vegetable and human."

In Victoria, she still felt lonely. She was fiercely jealous every time she heard about the eastern artists doing something together, but Harris insisted she was lucky to be so cut off. "Solitude is swell!" he cheered her. "Altogether too much chatter goes on."

Emily wrote cheering notes to herself in her journal. "Hail your fellow travellers from a distance," she advised herself. "Don't try to catch up and keep step. Yell cheerio across the fields, but stick to your own particular path, be it paved or grassed, or just plain old dirt. It's your path and suits your make of boots."

Harris continued to write encouraging letters from Toronto. "Your peculiar contribution is unique," he told her. "You can contribute something new and different in the art of this country."

Sometimes she had to scold herself. "Hadn't I always chosen solitude?" And yet, she mused, "I'd love an understanding companion," and underlined "understanding."

10

Success

Emily, don't you know by now that you're an
oddment and a natural-born "solitaire"? There
is no cluster or sunburst about you. You're just
a paste solitaire in a steel claw setting.
 – Emily Carr, *Hundreds and Thousands*

I n 1930 Emily made her last trip to northern British
Columbia. Not only was her art changing, but she
was almost fifty-nine years old. It is a sign of her extra-
ordinary commitment that she continued these rigor-
ous trips for as long as she did.

By now, she was beginning to exhibit more
widely. She had shown or would soon show her work

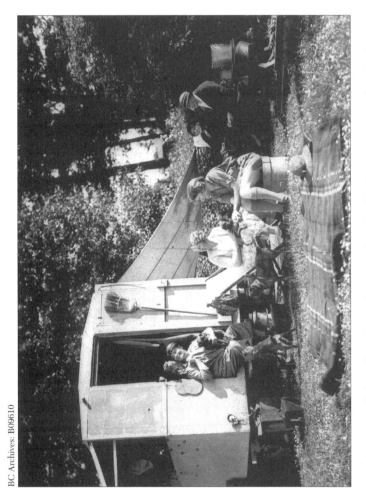

Emily Carr with friends and pets (Woo on her shoulder), camping in "the Elephant." Summers in the Elephant were some of the happiest in her life.

in Seattle, San Francisco, Washington, D.C., at the National Gallery in Ottawa (in 1929 and 1930 as well as in 1927), in the Ontario Society of Artists exhibitions, and finally, after an eleven-year gap, at the Island Arts and Crafts Society in Victoria. There were inquiries from Edmonton, Calgary, and Toronto and from American galleries in Rochester and Buffalo. The only city in which it was certain her work would be unwelcome was Vancouver. Art criticism there was very conservative, and "modern" artists like Carr and the Group of Seven were still ridiculed or ignored.

After Emily paintings received a favourable response at the 1927 show at the National Gallery, even Victoria had begun to soften. Eric Brown and Marius Barbeau both praised her work whenever they were in Victoria, and the local press now boasted about her. But Emily was suspicious. She thought her fellow citizens were not so much impressed by her work, as by the fact that people in the East liked it, and this hurt her.

In 1930, when Emily went east again to attend her first solo exhibition in eastern Canada – at the Canadian National Railway's ticket office in Ottawa – people in Ontario found her less shy and more confident. Everyone was enthusiastic about her work, including Lawren Harris, who talked to her again of how theosophy affected his life and strengthened his experience of nature. On this trip, Emily also overcame her dislike of large cities, which had not been kind to her in the past, and gathered her courage to visit the art galleries of New York. Briefly she met the American artist Georgia O'Keeffe, whose paintings she found

"beautiful." She especially liked *Lawrence Pine Tree, with Stars* and the *Jack-in-the-Pulpit* series.

∽

But in spite of these successes, the early 1930s were years of great struggle for her. In January 1931, Emily wrote, "My aims are changing and I feel lost and perplexed."

Spiritually, it was a time of religious search that – eventually – brought her back to Christianity. The 1930s were a time of economic depression with thousands of people homeless and unemployed, unable to afford high rents or sometimes, rents of any kind. With such unsettled conditions, many were willing to explore radical political, economic, and spiritual alternatives, including various Pentecostal and nontraditional religions.

Emily changed from being one who avoided churches to one who attended regularly, although she didn't go to churches of which her sisters would approve. The family's church was Reformed Episcopalian, but for a time, Emily was drawn to the Victoria Unity Centre, which had grown up during the Depression as an alternative to the materialism of the Christian church. She regularly attended services and faith healings and even unsuccessfully petitioned the Centre to bring the famous Father Divine to Victoria.[5]

5. Father Divine, a former gardener otherwise known as George Baker, was known for faith-healing and talks on the brotherhood of humanity and human dignity, particularly for black people.

She explored various philosophies and attended the lectures of several different religious speakers, always trying to see the divine "manifest" in nature so she could express this in her painting. She asked herself, "What is that vital thing the woods contain, possess, that you want? Why do you go back and back to the woods unsatisfied, longing to express something that is there and not able to find it? This I know, I shall not find it until it comes out of my inner self, until the God quality in me is in tune with the God in it."

∽

She drove herself hard, never letting herself get smug or comfortable. In Victoria she wrote, "My old things seem dead. I want fresh contacts, more vital searching." She wanted her things to "rock and sway with the breath and fluids of life" but worried that instead, "they sit, weak and still." In 1933 when she got some paintings back from an exhibition and had a chance to take a fresh look at them, she despaired again. "Oh, I am frightened when I look at my painting!" she exclaimed. "There is nothing to it, just paint, dead and forlorn, getting nowhere. It lacks and lacks. The paint chokes me and I ache."

As if to cleanse body as well as mind, she fasted on orange juice and eggs and pored over the poems of Walt Whitman and the essays of Ralph Waldo Emerson. She particularly liked Whitman's optimism and, no doubt, his joyous disregard for tradition. She learned sections of *Leaves of Grass* by heart – ignoring, of course, the "fleshy" bits. Some parts of Whitman

must have read to her as if he was spurring her on from the grave. "The earth does not argue," Whitman wrote, "Closes nothing, refuses nothing, shuts none out." These were certainly words that a woman who felt "shut out" for much of her life would have valued.

She constantly questioned the quality of her work. Although she craved compliments, she could hardly believe people who told her the paintings were good. "Why can't I take all the nice things they say like a dainty dish one is offered by a hostess?" But no, she was sure those who praised her couldn't know "good work" or how could they praise hers? And yet if praise didn't come from the right people, she flew into a fury and refused to speak or write to them, sometimes ever again.

∽

In the summer of 1931 she went to Goldstream Flats north of Victoria, to try to capture in her sketches the free, swinging motion of its large cedar trees. Perhaps their grace reminded her of the old cow ambling across Small's cow yard, the looseness of its red and white body swaying as if in a high wind. By now, Emily had a certain routine. She walked into the woods, perhaps tripping a bit, and looked for an open space in which to set her camp stool. When she found it, she simply sat and smoked a cigarette and waited. Slowly, things began to move. Air slipped between the leaves of trees, sunlight began to dance, and colours came out until everything was alive, full of sound and shape and shadow. Then, with her sketch board in front of her,

she unfocused her eyes a little, straightened her arm, and began to paint or draw with large, flowing strokes that echoed the sweep and ease of the cedar boughs dancing above her.

She was also using a different medium. In the past Emily had used artist's oil paints or charcoal, which worked well in the rain. But now, driven partly by financial need, she bought several one-gallon cans of good quality house paint, thinned them with lots of gasoline, and began painting on large sheets of Manila paper. Using broad bristle brushes she could get the fresh colour and quick drying effects of watercolour, with the colour intensity of oils. Most importantly, the cheaper materials let her feel free to play with her medium, to experiment and make mistakes. Many of the sketches she painted in this way were so full of spontaneity and energy that they became finished pieces, and Emily used the technique even in her studio.

Lawren Harris raved about these latest sketches, telling her they were "unusually individual" and "saturated with what you are after."

Emily was still running the boarding house, but it had ceased to dominate her life. She also had several dogs, but she didn't keep a commercial kennel. She had Woo, a cage full of chipmunks, and a cat. But finances continued to be very tight. Her two bottom-floor suites stood empty through the summer and fall of 1932.

In the fall of 1932 she caught her baker and a stranger peering in her studio windows. Furious at this invasion of her privacy, she raced out the door to the balcony where they stood.

"How dare you stare into my window? Go away."

The baker apologized and explained that, "We didn't mean to be rude – this 'ere feller," thumbing toward the stranger, "loves pictures. Come along, I sez, I'll show you!"

It gave Emily an idea. For some time she had thought Victoria needed an art gallery, although what she imagined was a noncommercial place where families of "all classes, all nationalities, all colours" could come to appreciate fine art. She imagined lectures and study groups and special help for young artists. If the cautious folk of Victoria's Island Arts and Crafts Society didn't like her art, maybe others would. She would give an exhibition for "ordinary" people and invite the general public.

"The People's Gallery," as she called it, was to be in the two empty suites on her main floor. She promptly had a door cut between them and hung an exhibition of her own with three other painters, including Lee Nam, who had been refused admittance to the Arts and Crafts Sketching Class.

The exhibition was so successful that several people began to work with Emily on the idea of creating a permanent People's Art Gallery, a place where ordinary people walking through Beacon Hill Park on a Sunday could drop by, rest at the open fire, and see some art before going home.

Emily sent out invitations, and on December 14, the day after her sixty-first birthday, a meeting was held at Hill House. About forty people were present, including several members of City Council, a few members of the Island Arts and Crafts Society, and a

reporter from the Victoria *Colonist*. Jack Shadbolt called the meeting to order.

According to the article published the next day in the *Colonist*, Miss Carr explained to those present that Victoria needed more exhibition space, space in which ordinary people felt comfortable and everyone felt welcome, including those who had been banned from the Arts and Crafts Society. (Presumably she meant people like the young Chinese artist Lee Nam, who had been banned "because of his nationality.") They didn't need a lot of money – the Gallery could be modest – but even a modest gallery required the financial and moral support of many people.

At first there was great enthusiasm. A committee was formed and donations called for. Emily offered to rent the Gallery to the city at the "lowest possible rent," and Eric Brown of the National Gallery in Ottawa promised to send exhibitions from the East.

But by January it was clear that although there was plenty of interest, the people with money were not willing to open their wallets. No doubt there was also some concern that eccentric, bad-tempered old Emily Carr might not be the most desirable curator of the place. It was finally decided that if Victoria couldn't produce something better than Vancouver's new art gallery, they would do nothing at all. Emily resealed her door and rented out the two lower suites.

In letters, she continued to ask Harris about his religion. She believed his God was the same as her own,

but she was worried by the fact that theosophists did not pray and denied the divinity of Christ.

On a trip to Toronto in 1933 she had several long talks with Harris and with Bess and Fred Housser about their theosophical beliefs. If she could understand their attitude to God, she thought, it might help her find her own way as an artist. But that night she slept badly. She awoke at 5:00 a.m. feeling "soul-sick" and "churned by the whiz of it." How could she live with no Bible, no Christ, no prayer as she had always known them?

Back in Victoria, she wrote and told Harris she could not accept theosophy. Emily went back to the "plain Bible" of her childhood faith, and they never mentioned the matter again.

But she believed more firmly than ever that there was a spiritual quality to art. The artist didn't have to be religious in the organized sense; to be deeply sincere was itself a religion. What was vital was to find and tap into the "one substance, one life...that flows through all."

What she now sought for herself, with all her heart and body, was a way to express that sense of something beyond the material, to be a channel, "clear, open, receptive" as she searched for the "divine" in everything.

∽

Emily's oldest friends were still her sisters, although Edith had died in 1919. "The girls" – Lizzie and Alice – were very different from Emily and each of the three

women was impatient and critical with the others, but they were tied to each other by the bonds of family, habit, and affection. It pained Emily that her sisters didn't like her art in the ways she wished they would, although she still thought they were "the finest women ever."

All three sisters lived within easy walking distance of each other on the original family acreage, so it was easy to get together every Sunday at Alice's schoolhouse for dinner, for birthdays, and for Christmases. As long as she was a landlady, Emily also tromped over for frequent lunches and to visit.

Over lunch, as she recited the latest atrocities of her tenants, Alice would say little, Lizzie would side with the tenant, and there would be a clash. Usually Emily was told to behave as a good landlady and sent right back, and she felt yet again like the unsuccessful black sheep of the family. But her sisters remained her closest friends, and it was a great joy to her when, in 1933, Alice finally said that she thought some of Emily's sketches were "wonderful." Lizzie later also saw something she liked in Emily's work for the first time.

Other old friends included Willie Newcombe, the son of Dr. Newcombe who had inspected Emily's paintings for the provincial government in 1912. Willie was a friend, a naturalist, and a handyman.

Flora Burns was the daughter of one of Emily's earliest supporters in Victoria. In the 1920s, when Flora and Emily confessed to each other that they both liked to write, they took a correspondence course together. They read their short stories to one another

and exchanged criticisms. Later, Ruth Humphrey, an English teacher at Victoria College, and Margaret Clay, a librarian at the Victoria Public Library, also gave Emily feedback on her stories. Emily called them her "listening ladies."

Their job was mostly to cheer Emily on – a role with which Emily felt comfortable. She didn't like competition or criticism, which may be partly why her friendships with several young Victoria artists in the 1930s were not very happy. Max Maynard, Jack Shadbolt (later one of Canada's leading painters), and John McDonald all liked to come to her studio, see her latest work, and talk about art. All three thought her work some of the best in the province and acknowledged her influence on their own art.

But their easy male confidence intimidated her. Emily was always uncomfortable with art criticism, and as the men talked – "spouting jargon" as she called it – she felt more and more stupid. She became increasingly abrupt with them. When she saw signs of her influence in their work, rather than take it as a compliment (young artists modelling on an older one), she was sure they were stealing her ideas.

Part of her defensiveness may have had to do with arrogance on their part. Maynard once told her women can't paint. Emily, he quickly explained, was an exception. But Emily had heard too much of this sort of talk before. When the men moved to Vancouver, she found it easier to be friendly from a distance.

Always, if Emily felt under attack, she snapped back. She could be a good friend, but she lost her temper easily – and was often sorry after. In her fear of

being rejected, she rejected others first, before they could reject her – or her work. The one artist with whom she was close at this time was Edythe Hembroff. They met when Emily read in the newspaper that Edythe had just come back from studying art in France, and invited her to tea. The two were different in many ways but they liked each other immediately, and for three years they painted together almost every day.

During the early 1930s Emily became distanced from the members of the Group of Seven. Partly this was because of her own sharp temper and her quickness to feel slighted, but partly also it was her increasing confidence in her own work.

Officially, the Group had dissolved and formed a larger organization, the Canadian Group of Painters, of which Emily was a charter member. In 1933 when she sent sixteen of her new paint and paper sketches east for their comments, Emily was disappointed in their feedback. She thought the freshness and courage of their earlier painting was gone and that none of them had changed their style, while Emily's continued to develop. For years she had been dependent on their criticisms but soon she would write in her journal, "Now they are torn away and I stand alone," ("alone" was underlined), "on my own perfectly good feet. Now I take my own soul as my critic."

She even suffered a cooling (though never an end) to her relationship with Lawren Harris. When Bess Housser and Lawren Harris announced their plan to divorce their spouses and marry each other, Emily was deeply offended. She always held conservative sexual

attitudes and although she liked them both, she felt she couldn't trust them again. Harris continued to write to Emily, and (after 1940, when he and Bess moved to Vancouver,) to visit her, but their relationship was never the same.

This was partly because Emily was beginning to see some of the differences between Harris's work and goals and her own. His paintings, she thought, were too cold, too finished, almost static. "They take you to their destination and leave you," she said. In her own work, movement was now all-important. She was trying to make her paintings express the heat of "growing, not stopping, being still on the move."

But she never stopped acknowledging his importance to her. Just before her death she wrote of him that his "work and example did more to influence my outlook upon art than any school or any master."

∽

Emily was developing a new style, one in which rhythm was dominant. Perhaps as a reflection of her growing spiritual confidence in the "continuous process of life, eternally changing," her paintings lighten. Space is no longer heavily carved but moves. In 1930 in New York she had seen Georgia O'Keeffe's *Jack-in-the-Pulpit* series of paintings. Now, in the canvas, *Tree*, Emily, like O'Keeffe, focuses the viewer in tight, to a single aspect of the tree, emphasizing the grace of its rising trunk with only a glimpse of green draperies falling around it. This painting also shares the feeling of inner tension of the totem poles. When describing forest, she exclaimed

how it affected her, "surging with being, palpitating with overpowering, terrific life, life, life." Emily also began to look above the trees to the sky, which she sought to make "roomy and moving and mysterious." She still painted totem poles – mostly from older sketches – but this work, too, showed a new confidence, a new rhythm, as if she was now seeing the totem poles through her own eyes.

Until now, her sketching trips around Victoria had been limited by where she could find a cabin to rent, but in 1933 she solved that problem. Ever since she was a child reading stories about the gypsies or Roma people, she had dreamed of owning a caravan. Now, with the proceeds from the sale of one of her paintings, she bought a rickety trailer, dubbed it "the Elephant," and built in it a bed for herself, sleeping spaces for the animals, a meat safe, kerosene stove, and bookshelves. She also built a large canvas tarpaulin on one side where she could cook and heat the water for her hot water bottle on rainy days.

Now every spring and fall Emily had the Elephant towed to some place near Victoria where she spent several weeks sketching. She felt, she said, like "Mrs. Noah" with all her creatures – including Woo the monkey, happily ensconced in a tree, and Susie the rat, tucked into a corner in her oatmeal container.

Susie travelled everywhere with Emily, partly because no one else could stand her. Lizzie and Alice had finally come to accept Woo, the monkey, even though she once kept Alice cornered for hours in the back shed. But a rat was a rat, and the sisters wouldn't have it near them. So Susie stayed in the oatmeal

carton or kept Emily company inside the collar of her jacket as Emily sketched. The animal was so devoted that she wouldn't leave, even if the Elephant's door was left open. In Victoria, if her cage in the studio was not securely locked at night, she'd struggle up the steep studio stairs to sleep on Emily's pillow.

The first time Emily lumbered out in the Elephant was in the late summer of 1933, back to Goldstream Flats. She confided to her journal how on most nights, when everyone else was in bed, she put on a "nondescript garment" and lay down on the stones in the river for her bath and let the water ripple over her sixty-two-year-old skin. When she was "scrubbed down with a hard brush" and back in bed with a hot water bottle, she felt "like a million dollars" with everyone peacefully asleep and the trees and river whispering around her. Outdoors was always where she felt happiest.

It was on these trips in the Elephant that Emily finally found a way to express the moving spirit she had been seeking in nature. She had a dream in which she saw an ordinary wooded hillside suddenly come alive, "weighted with sap, burning green in every leaf." After that, she said, "growing green" became something different to her.

For the next few years, in paintings such as *Above the Gravel Pit*, *Scorned as Timber*, *Beloved of the Sky*, and *Sky*, all the elements of her painting came together to show flow and rhythm, what she called the "organized chaos of growth." She had come to terms with

her fear and was painting her own vision. When the weather was bad or if she wasn't in the mood to sketch, she wrote stories. "These were the happiest days of my life," she later said.

Lawren Harris now urged her to take the next step and move into the purely abstract, as he had done, away from the representation of actual objects and into a landscape of curves and cones. But Emily held back. Though she was very interested, she wasn't entirely sure what Harris meant when he talked to her of "abstraction" in art. She knew that when she looked at his work she was moved. She was afraid that if she left forest images, her own work would be merely decorative. Instead, she "clung to earth...her density, her herbage, her juice" and continued to paint the familiar, identifiable forest.

No doubt this was partly because, with all her Victorian prudery, Emily Carr was an extraordinarily physical woman. One of the reasons her writing is so powerful is because it is full of "juice" – smell and texture and passionate action – including the sharp call of crows, the smell of sea salt and fish, the lash of rain coming down "in long streaks like macaroni."

Whenever she felt bad, she sought reassurance in physical activity. As a landlady, when it was too early in the spring to sketch outdoors, she diverted her impatience into a furious spring cleaning of the entire house that included putting fresh calcimine on the walls, scraping and varnishing floors, washing and ironing curtains, scrubbing pots, and dusting inside closets. Alone, or occasionally with the help of a handyman, she heaved unwanted furniture and used

household items out of the top-floor windows to take to the dump later. In all this she took a certain sweaty, concrete pleasure.

She always found comfort in the physical world. At the end of her life when people brought her flowers, she had to touch them, and if there were no flowers, she would ask to hold an ordinary twig with leaves on it. In this way, landscape was a natural extension of her own passionate body, her own passionate life.

∽

Oddly, now that praise for her work was beginning to pour in, Emily cared much less. The praise that had most moved her had always been that of ordinary people. She would spend hours in her studio with an old couple who came in to try to understand modern art, but anyone the least bit pompous or condescending got her back up; she would set the clock ahead to make them leave, or let Susie loose, or refuse to lower the chairs from the ceiling so they would get tired and go away. Always suspicious of whether compliments were sincere or not, even when she was desperate for them, now she was suspicious for a different reason –afraid that praise would make her lazy in her art.

She was tireless in pushing herself to work harder, to reach deeper and higher, to seek the spirit in everything she painted. "I do wish I could feel *satisfied* just once over my work," she mused in 1934 at a time when she was producing what many people think are some of her most stunning pictures. "It's so faulty and poor," she mourned.

In 1935 she put Hill House up for sale. It was twenty-two years old and badly needed repair. Because it was the Depression, she couldn't sell it outright but traded it for another house she rented for twenty-five dollars a month. Then she found a small cottage at 316 Beckley Avenue that she could rent for herself to live in for twelve dollars. The resulting thirteen-dollar profit was a major part of her income for the next few years.

Willie Newcombe helped her get the Beckley Avenue cottage ready: he built racks for her paintings, a chicken house in the back yard, an aviary on the porch, and cages for the animals in the kitchen. Her woven rugs warmed the floors.

At first she found it lonesome to live alone, but slowly she got to know her neighbours, including the six-year-old girl next door. Once young Phyllis Hudson spotted Woo in the tree in Emily's back yard, she wouldn't stay away. She waved to Emily every time she saw her. After Emily invited her to watch the dogs having a bath, Phyllis became a constant and irrepressible visitor. As affectionate, noisy, and sensitive as Emily herself, Phyllis riled the dogs, tracked over clean floors, forgot to close the front gate, and was a "waggle-tongue," but she was a happy one and Emily adored her energy and imagination.

But this settled happiness wouldn't last. In August 1936 Emily's oldest sister Lizzie died of breast cancer, and in January of 1937, Emily had a heart attack and was suddenly rushed to hospital.

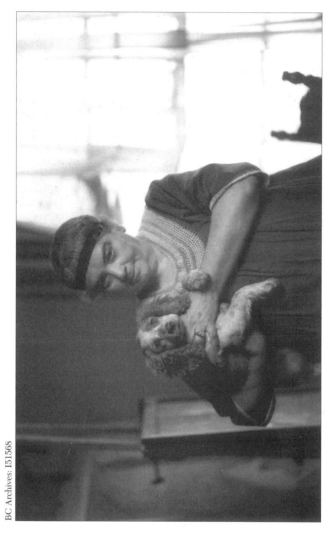

A Christmas card for Ira. The caption on the back reads:
"Lady June...and Emily Carr wish Ira Dilworth a Merry Christmas, 1942."

11

Solace

> I am always watching for fear of getting fee-
> ble and passé in my work. I don't want to
> trickle out. I want to pour till the pail is
> empty, the last bit going out in a gush, not in
> drops.
> – Emily Carr, *Hundreds and Thousands*

It was the Depression. Emily had very little money and there was no health care plan to pay for a doctor or medical bills. When her friends realized how serious the situation was, they contacted each other and soon Emily began to receive cheques from picture sales adding up to almost three thousand dollars. Her basic

income was fifty dollars a month, out of which, when she moved yet again – into Alice's house – she would pay fifteen dollars to Alice as rent and another twenty to thirty dollars to a housekeeper. She also paid living expenses, taxes, and maintenance on the house. The relief from financial worry brought by the money from art sales, as well as many letters from friends and supporters, all helped her recover. The woman who in 1933 thought she had no friends suddenly realized she had many.

This was important because her health was no longer good, and she was not old enough for a pension. In those days before Medicare, RRSPs, or even welfare, people had only family and friends to rely on in times of illness. Emily was overweight and partially deaf; her knees, hips, and back were often stiff and her ankles swollen. She claimed a touchy liver and gall bladder made her bad tempered, and now she also had developed heart problems.

She could no longer look after all her creatures, so with great sadness, she asked Willie Newcombe to find new homes for them. Woo went to the monkey house at Stanley Park in Vancouver, where she lived for a few more years. Only one or two dogs and a few birds and chipmunks were left when Emily came home from the hospital.

It was clear that although she was still able to do some work, both painting and writing, she was not strong enough to live alone, and now began a long line of housekeeper-nurses. Emily was quick to find fault with all of them. She was ill and therefore impatient, and their youth bothered her. There were frequent fights and tears on both sides and firings and hirings,

all complicated by increasing demands for her to exhibit. This meant crating and shipping pictures (with Willie's help), then worrying when galleries were slow to return them.

Four of her paintings were in a large exhibition of Canadian art in London, and Emily and Tom Thomson, an early influence on the Group of Seven, were the two painters most frequently mentioned by critics. Closer to home, Eric Brown persuaded Nan Cheney, a friend of Emily's, to arrange a solo exhibition for Emily at the Vancouver Art Gallery.

Emily was very nervous about it; this was the city that had harshly criticized her in the past. But the show was a huge success. Emily couldn't resist. Four days after the opening she took the morning ferry to Vancouver to see the show herself and to hover, unnoticed, listening in on people's candid responses – the only ones she could really trust. When she came home she was exhausted but thrilled – finally the most artistically conservative people of British Columbia had seen their province through her eyes and accepted what they saw.

Between 1938 and 1940 Emily made four more sketching trips, but she was working much more slowly. Her poor heart forced her to spend regular days in bed, and she could no longer keep three paintings on the go at one time. It took weeks instead of days to prepare canvases, and having to rely on other people to buy the right materials and lumber in town left her furious. In March 1939 she had a stroke that put her in hospital for several weeks, but within a few months she was out sketching again.

The pressure to keep producing new work worried her. She was working for fewer hours with less strength and going on fewer sketching trips. How long could she continue? Even more important, would her art become weaker along with her health? In fact, there was some criticism – including from Jack Shadbolt – of "occasional lapses" in her work. But when Shadbolt made a comment to this effect at a public lecture in the Vancouver Art Gallery, it nearly caused a riot. The tide had turned.

∞

Now, partly to escape her fears, partly because it was easier on her physically, Emily turned to writing.

She had studied writing since the 1920s, first in the correspondence course then in short story writing workshops. In her very first class, Emily's story, "The Hully-Up Paper," was voted best in her class, and she read it at the graduation exercises.

Writing stories, she said, made her "forget being sick." Wrapped in a shawl and with a hot water bottle to keep her feet warm, she would prop herself up in bed. Then she balanced a child's scribbler on her knees and with a pencil in one hand and toffee candy in the other, let herself drift back in time.

She produced amazing quantities of writing in a very short time. Within a few months of her 1937 attack, she finished her Indian stories. By the end of the year she had a first draft of her boarding house memories, and in 1938 she wrote the story of her life in the English sanatorium. By the end of that year there

was a collection of childhood stories. She went on to write stories about Woo, two autobiographies, more childhood stories, and several others, in addition to her regular journal entries and a large personal correspondence.

Her editors had their work cut out for them. Emily used slang, like "dame" and "busted." She was impatient and she swore. She muddled syntax and grammar and scrambled her words. Her best spelling was almost unreadable and her eccentric punctuation didn't help. Her first drafts were wordy and had to be drastically cut. But she slowly learned how to become a better editor of her own work.

She followed two good rules, the same, she said, as the principles she used in painting. They were: first, "Get to the point as directly as you can;" and second, "Never use a big word if a little one will do." Perhaps as a result, her writing is colourful, spare, fresh, and as full of energy as her later paintings. She knew intuitively that being "ultra-honest" was more important than mere mechanics. It was better, she said, to say "*something* poorly" than "*nothing* politely." And say something, she did. But as with all writing, it turned out to be easier to write the stories than to get them published.

With the help of her listening ladies she first attempted to publish individual stories in magazines such as *Maclean's*, *Saturday Evening Post*, and the British *Countryman*. All of them turned her down. She was disappointed but it helped that by now she had a well-honed contempt for popular taste. She'd experienced too much of it in her early newspaper reviews.

She didn't *want* to write popular "sex and crime" stories, she said, and this helped her handle the rejection slips.

She reorganized the individual stories into collections with certain themes. The first, of her adventures in the northwest, was sent to Macmillan of Canada in 1937. They rejected it but recommended Ryerson Press. Ryerson, in the course of moving offices, promptly lost the manuscript. When it was found almost a year later, Emily received another rejection notice. Her reader thought the author was observant and wrote well but doubted the manuscript would have wide appeal; in fact, he said, it depressed him.

Emily was furious, but Ruth Humphrey took the manuscript to Ira Dilworth in Vancouver. Dilworth, a former instructor in English at the University of British Columbia, was now a director of the Canadian Broadcasting Corporation (CBC) in Vancouver. Both Dilworth and Garnet Sedgewick, head of the English Department at the University of British Columbia, read some of Emily's stories on CBC Radio. Emily was pleased.

∽

One month earlier, when she learned her landlady was selling the cottage on Beckley Avenue, Emily decided without consulting her sister that she would move in with Alice, who by now had very poor eyesight. Now that Alice, who was seventy, had retired from teaching, half her house stood empty and couldn't be rented, so it seemed only appropriate to Emily, who was only

sixty-four, to move in and look after her older sister. Perhaps she forgot that Alice had refused to live with her before.

Emily launched into major renovations: a new bathroom, bedroom, and kitchen, and space for her paintings, birds, and dogs. When she volunteered to have the house painted, Alice said no. Emily went ahead and painted her own half anyway, inside and out. Alice complained the house didn't feel like home anymore. Undaunted, Emily carried on; she took Alice's schoolroom for her studio and Alice's spare room became the maid's room. Alice settled into what was left, and in February 1940, Emily moved in with her.

Things were not smooth. The two were very different from each other and Emily was never easy to get along with – but their mutual affection overrode most differences. Carol Pearson asked Emily to come live with her in Ontario, but Emily would not leave Alice. Shortly after the move, Emily had another heart attack, but she was still able to go sketching at the Metchosin gravel pits in May. When she came home, she had a major stroke.

Once more she was rushed to hospital. The stroke impaired her speech and her sight and left her face and left leg paralyzed. Two months later, when Humphrey Toms – a young teacher friend – visited her at home, he was deeply alarmed. Emily lay in a dark room, not moving, and she could barely speak. She was so upset because she couldn't work that she wished she could die.

Ten days later, Toms couldn't believe the difference. When he arrived at her house, Emily was

shouting at the maid from the back porch. Handy as always, she had put wheels on a butter box as a sort of wheelchair for herself. A second box was a table for her typewriter. By August she was writing again.

In June, Ira Dilworth took some of her northern and childhood stories to the Oxford University Press in Toronto, where the editor said he liked them but they might better suit magazines. Emily was lucky at this point that she had someone to promote her work for her or she might have given up. The magazines had already said no.

Dilworth, undaunted, sent them to the manager of the press, W.H. Clarke, who finally agreed to publish not just one but both books. Emily was delighted.

∽

Both Ruth Humphrey and Flora Burns were still suggesting corrections to Emily's writing, but increasingly this work was taken on by Ira Dilworth. While Emily read, Dilworth corrected her terrible spelling, grammar, and punctuation. In the process, they rapidly became close friends. Dilworth was like Emily in many ways: both of them had been raised in Victoria, and both were very proud to be from Western Canada. Both of them were private people, often lonely, who loved solitude and had strong religious faith. Both felt that spirituality was an important part of art.

Dilworth had great admiration for Emily's writing, and although he was much younger than Emily, he quickly filled the role of friend and confidante that Lawren Harris had played for a while in her life. In

some ways, Dilworth was even more appropriate as a friend because he was single. In their many letters (Dilworth lived in Vancouver) they were very open with each other, discussing everything. Again, it was doubtless good for their friendship that they weren't in the same city, so Emily's demands were not overwhelming. Dilworth was very busy as both regional director of the CBC and conductor of the Vancouver Bach Choir, but still he frequently visited her, corrected her stories, negotiated with her publisher, and kept up his half of a busy correspondence.

Emily helped a little by categorizing her letters: there were N.N.T.A. (Not Necessary To Answer) letters, R.A.L. (Read At Leisure) letters, "Red Hot Specials," "Week Enders" and "Special Deliveries."[6] She called him "Ira" and gave him affectionate nicknames like "Eye." Sometimes, when she pretended to be back in her young, playful child-self, Small, she called him "My Beloved Guardian."

In spite of the twenty-year gap in their ages, they signed their letters with love. Not "flesh love," Emily said, but "something beyond." It was a love built on respect, trust, kindness, joy – and distance. Emily kept his letters in a bag by her bed to cheer her when she was "down." She had finally found the deep companion she always yearned for. It was to Eye that she confessed the secret she'd never told anyone before, about the trauma of her father's "brutal telling."

6. Maria Tippett, *Emily Carr: A Biography* (Toronto: Oxford University Press, 1979), page 260.

☙

Klee Wyck, dedicated to Emily's old friend, Sophie Frank, and describing some of Emily's northwestern adventures, was published in October 1941. By Christmas, 2500 copies had almost sold out, and in the following year it received Canada's highest literary honour, the Governor General's Award for non-fiction.

The publication of *Klee Wyck* was celebrated on Emily's seventieth birthday with "a little tea-party" given by the Victoria Branch of the University Women's Club. Emily figured it would be "a half dozen ladies and a cup of tea," but when she and Alice arrived, they were greeted by a large room full of people.

Someone said a prayer, then the master of ceremonies read several letters of congratulations, including from the Lieutenant-Governor, the Premier of the province, and the Indian Commissioner of British Columbia. Emily was given several corsages and bouquets of flowers. "It was like having a beautiful funeral," she said, "only being very much alive to enjoy it." She was having a good time.

There was a pause, then Emily stood up. "Thank you everybody," she said, "for giving me such a splendid, happy birthday party and for being so kind to *Klee Wyck*. I would rather have the good-will and kind wishes of my home town, the people I have lived among all my life, than the praise of the whole world."

Ira read from *Klee Wyck* and tea was served. When Emily cut the cake, everyone sang "Happy Birthday" and later, "Auld Lang Syne" and "For She's a Jolly Good Fellow" and "God Save the King." But the

high point for Emily came when Ira crossed the room, bent, and in front of everyone, kissed her cheek. His "kiss for Canada" was, she said, "the proudest moment of *Klee Wyck's* success."

She was already hard at work on her next book, a collection of childhood stories to be called *The Book of Small*.

∽

In June, after several months in a rest home, she spent three weeks working with Dilworth on *The Book of Small*. She also went on another sketching trip, this time to Mount Douglas Park near Victoria. Too ill now to manage the Elephant, she stayed near a teahouse that provided all her meals. She took writing and painting material, books by Whitman, Keats, and Emerson, and, so she would not be without a creature as company, Dilworth's dog.

On this trip she was particularly moved by the cedar trees, their sensitivity to colour in different lights and their changes of shape. When she ran out of light to paint by, she wrote. Within eight days her poor health forced her to stop, but she had produced more than fifteen large (plus many small) oil-on-paper sketches, one of which was the powerful canvas, *Cedar*.

In August she was again rushed to hospital. She was in great pain from a clot on her heart, and the doctors ordered complete rest. When she was moved to the nursing home a few weeks later, one of her visitors described how Emily continued to work. She wasn't

able to sit up, he said, so she lay on her back with a piece of paper on her knee, writing blind. Then she typed the story on a typewriter hung from the ceiling above her bed.

When it was printed that fall, *The Book of Small* immediately sold out and was reprinted by January 1943. Magazines and newspapers proclaimed it the Canadian Book of the Year.

∽

Emily's success in writing was reflected in her painting. In 1943 she had solo exhibitions in Vancouver, Montreal, Toronto, and Seattle. All of them were enthusiastically received, including by Lawren Harris, who wrote to Emily of his great pleasure at the continuing growth in her work.

By now she administered her own morphine and took pain pills she called "weepers." At home, only a budgie and a chipmunk were left of all her creatures. Somehow she managed to continue writing.

In 1943 she and Ira finished the stories that would become *The House of All Sorts*. She trusted Dilworth implicitly when it came to making decisions about her writing, but the same did not apply to her paintings. When he tried to retitle some of them, she let him know that such changes were not welcome. Her titles remained.

In 1944 Emily rallied and managed to spend a few hours a day painting. She was delighted that *The House of All Sorts* was published and that it included stories of her kennels, "Bobtails," dedicated to Alice. For the

first time, her paintings began to sell in a commercial gallery – the Dominion Gallery of Montreal. This was arranged by Max Stern, who selected about sixty of her works, mostly the early Indian and French water-colours.

When Emily had yet another stroke, she continued to work for short periods of time, both writing and painting, preparing for a spring exhibition at the Vancouver Art Gallery that was not to be. She died of a clot on her heart, on the afternoon of March 2, 1945.

By her will, Ira Dilworth was her literary executor, with custody of all her manuscripts and letters. Willie Newcombe and Lawren Harris were appointed joint trustees of her paintings. Some of them were donated to a permanent collection in the Vancouver Art Gallery; others were sold to pay for insurance and packing costs and a scholarship for B.C. art students. Some, including many of her early works, were selected by Harris to be destroyed.

After Emily's death several more books were published: her autobiography, *Growing Pains*, which was dedicated to Lawren Harris; *Pause: A Sketchbook*, about her stay in the British sanatorium; and *The Heart of a Peacock*, another collection of northern and animal stories. The final piece published by Dilworth was the transcript of a talk she gave on modern art at the Women's Canadian Club in Victoria in 1930. Her journals, *Hundreds and Thousands*, were not published until after Dilworth's death, in 1966.

The last entry in Emily Carr's journal is dated March 7, 1941. She acknowledges the terrible war going on in Europe and then describes the intense

pleasure of a spring drive in the park, particularly the joys of bird song. No matter what terrible things are being carried out by humans, she says, life and the birds cannot be stopped. "Instinct bids them carry on." The journal ends, "They fulfil their moment; carry on, carry on, carry on."

Emily Carr is buried in the Carr family plot in Ross Bay Cemetery in Victoria, British Columbia. For many years her grave was a concern to Alice because the grass would not grow over it. The grass seed was continually scattered by birds that insisted on taking their dust baths there. Emily would have been pleased.

Afterword

Goodbye to D'Sonoqua

> If we give out what we get, more will be
> given to us. If we hoard, that which we have
> will stagnate instead of growing.
> – Emily Carr, *Hundreds and Thousands*

Emily Carr met the figure of D'Sonoqua for the last time in 1930 in a deserted Kwakw<u>a</u>ka'wakw village on Quatsino Sound. The man who dropped her off there couldn't understand why anyone, let alone a solitary white woman, should want to go there.

"There is nobody there," he said.

There is D'Sonoqua, Emily thought.

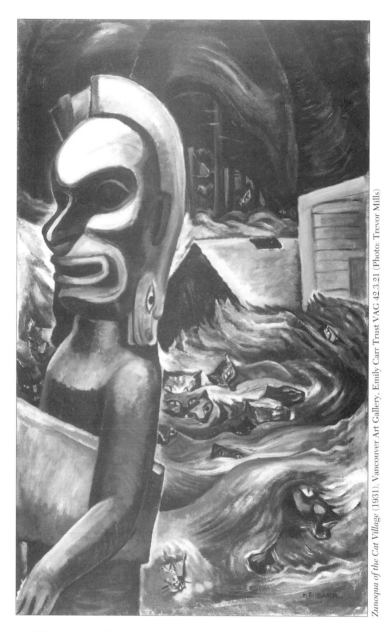

The last time Emily met D'Sonoqua was in another deserted village, this one filled with cats. She would never know the figure, whom she loved, wasn't D'Sonoqua at all.

The keel of their small boat had barely touched the beach when Emily was shocked by a small furry bundle that sprang into the boat. It was a cat. With a curse, the man hurled it into the water. Disapproving, Emily asked him to, "Call for me at sundown," then jumped ashore and crossed the beach with the cat following. She noticed that it was not a scrawny wild thing but rather a sleek Persian. Her little dog, who usually allowed no strange cats near his Emily, paced quietly beside it.

Like most villages, this one was old, decaying and falling down. As Emily pressed through the nettles that grew between houses, the cat followed, purring and rubbing against her legs. Soon there were two more cats.

Behind the houses was an impassable wall of old and new growth. A bright sun drew out the stink of skunk cabbage and slime on the still water around the buildings. When a single eagle circled overhead, Emily called, "Tell D'Sonoqua…" and turning, saw D'Sonoqua herself reaching high above her.

This D'Sonoqua had been carved as the housepost of a now burned-out lodge, a simple figure of red cedar, bleached by the weather. She felt to Emily more like "a singing spirit, young and fresh," "graciously feminine" rather than violent or frightening. The sticking-out ears were hidden by the figure of the Sistheutl, a supernatural two-headed sea serpent. One of its heads fell to each shoulder, framing D'Sonoqua's face in what Emily saw as great womanliness and making the forest seem a newly welcoming place.

As Emily sat down to sketch, dozens of cats appeared out of the underbrush all around her. They

purred and rubbed against her legs, curled up in her lap, pressed all around her as she worked. It was a moment of completion for Emily as she thought back to the time in 1912 when she first met the wild woman of the woods. That was a time of terror, when she was just beginning her journey. Now, many years later, she found the figure not terrifying at all but only "wild in the sense that forest-creatures are wild – shy, untouchable."

∽

In fact, a native elder pointed out many years after Emily's death that the resulting picture she called *Zunoqua of the Cat Village* wasn't D'Sonoqua, the wild woman of the woods, at all, but a male ancestor of the G̱usgimax̱w family that owned the house.

Perhaps it is appropriate. Emily's great love and respect for totem poles and for the forest that helped inspire them, could not, in the end, be entirely accurate. She was the first to admit that the native designs she copied in her paintings and watercolours and on her clay pots were not originally hers. She attempted to honour and preserve them, to bring them to the attention of, and perhaps to gain the respect of, other non-natives.

"Indian art broadened my seeing," she later said, "loosened the formal tightness I had learned in England's schools." But inevitably she stumbled. No matter how accurately she tried to reproduce it, to honour it, she made mistakes.

Emily probably never knew that the ancient European tradition from which she came also had a

"wild woman" figure. This wild woman has many names in many different cultures. She is the patron spirit to painters, writers, dancers, singers, and all creative women – "wild" in the sense of being from the root, true to their deepest selves. A creative woman who listens to the wild woman's call hears her own inner truth. As long as she holds to that truth she will blossom and thrive.

All her life Emily Carr found solace in the silent company of nature. The only voices that did not condemn her, did not try to mould her into something other than what she was, were the songs of birds, the rustle of trees, the noisy delight of children, and the quiet company of native people.

The totem poles, especially the wild woman figure of D'Sonoqua, gave Emily Carr courage. They led her into the British Columbia forest, where she would never have gone without them. They taught her to "dig deeper," to seek the power "behind it all," the spirit within that unites all things. In that quest, there is no doubt Emily Carr was successful.

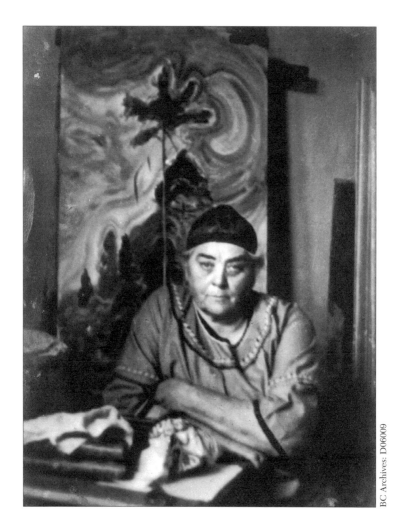

Emily in her studio with her painting, *Sunshine and Tumult*. A clear channel, seeking the "one life...that flows through all."

Chronology of Emily Carr (1871-1945)

Compiled by Lynne Bowen

EMILY CARR AND HER TIMES	CANADA AND THE WORLD
1848 A gold rush brings Richard Carr (Emily Carr's father) from England to California where he makes a fortune. Later he meets Emily Saunders and they travel to England to be married, then return to California.	**1848** Paul Gauguin, future French post-Impressionist painter, is born.
	1854 American author Henry David Thoreau publishes *Walden, or Life in the Woods*.
	1855 American poet Walt Whitman publishes *Leaves of Grass*.
	1858 Victoria booms as miners bound for the Fraser River gold rush flood in to buy supplies.

Emily Carr

EMILY CARR AND HER TIMES	CANADA AND THE WORLD
1859 Victoria's Beacon Hill Park, an important landmark in Carr's life, is reserved for public use by James Douglas, Governor of the Colony of Vancouver Island.	**1859** Georges Seurat, future French painter and founder of neo-Impressionism, is born.
	1862 The city of Victoria is incorporated.
1863 Unwilling "to live under any flag other than his own," Richard Carr moves his family to Victoria.	
	1867 Canada becomes a country as Ontario, Quebec, Nova Scotia, and New Brunswick unite. Pierre Bonnard, future French painter and graphic artist, is born.
	1869 Henri Matisse, future French painter and sculptor, is born. Sophie Pemberton, future Canadian painter, is born in Victoria, B.C.
1871 The eighth of nine children, Emily Carr is born in Victoria, B.C. on December 13.	**1871** In Canada, British Columbia (B.C.) joins Confederation; its population of 40,000 consists mostly of First Nations people.
	1872 Ontario Society of Artists is founded.

EMILY CARR AND HER TIMES

CANADA AND THE WORLD

1873
James Edward Hervey (J.E.H.) MacDonald, future Canadian painter, is born in Durham, England.

1875
Theosophical Society is founded in New York by Helena Petrova Blavatsky.

1879
Carr begins to attend school; she takes art lessons at Mrs. Fraser's Private School; then goes to Central Public School.

1879
In Canada, the native population of B.C. has fallen by 15,000 in a decade; Mungo Martin, future Kwakiutl carver who will be instrumental in the modern revival of carving, is born c.1879-82 in Fort Rupert, B.C.

1880
Royal Canadian Academy of Arts is founded; new member artists are required to donate works, which become the core of the collection of the National Gallery.

1881
Frederick Horsman Varley, future Canadian painter, is born in Sheffield, England.

Fernand Léger, future French cubist painter, is born.

1882
B.C. government gives Carr's beloved Beacon Hill Park to the city of Victoria in trust.

1882
Alexander Young (A.Y.) Jackson, future Canadian painter, writer, and nationalist, is born in Montreal.

EMILY CARR AND HER TIMES	CANADA AND THE WORLD
	Georges Braque, future French painter and co-founder of cubism, is born.
	Ralph Waldo Emerson, American philosopher and poet, dies.
1883 (approx.) Richard Carr explains sex and reproduction to Emily in such a way that she will later call it "the brutal telling"; she begins to oppose him.	**1883** Marius Barbeau, future Canadian folklorist and ethnologist, is born.
	Édouard Manet, French painter whose work influenced the Impressionists, dies.
	1885 Future Canadian painters Lawren Harris (Brantford, Ontario) and Arthur Lismer (Sheffield, England) are born.
1886 Carr's mother, Emily, dies; her stern eldest sister, Edith, takes over the daily care of the family.	**1886** Mary Dignam of Toronto forms the Art Club with a few friends; the club becomes the Women's Art Association of Canada (WAAC).
	1887 Marcel Duchamp, future French painter and sculptor, is born.
	Georgia O'Keeffe, future pioneer of American modernist painting, is born.
1888 Carr's father, Richard, dies; he leaves a trust fund for his six surviving children and names James Lawson as their guardian.	**1888** Ethel Wilson née Bryant, future Canadian writer and one of the first to capture the beauty of B.C.'s rugged landscape in words, is born in Port Elizabeth, South Africa.

EMILY CARR AND HER TIMES

1889
Carr completes her first year at Victoria High School; she asks her guardian to send her to art school in San Francisco.

1890
At the California School of Design, Carr begins three years of study in drawing, portraiture, still life, and landscape painting.

1893
Carr returns to Victoria and teaches children's art classes in a "barn studio" on the family property.

1894
Carr wins a prize for her drawings at the annual Victoria Agricultural Fair.

1895
Carr again wins prizes at the agricultural fair.

The Carr sisters are among the B.C. founders of the YWCA; their house is the Victoria headquarters.

CANADA AND THE WORLD

1890
Franklin Carmichael, future Canadian painter, is born in Orillia, Ontario.

1891
In Canada, Massey-Harris Co. Ltd. is the largest manufacturer of farm machinery in the British Empire; the first Canadian branch of the Theosophical Society is formed in Toronto; Sarah Robertson, future Canadian painter, is born in Montreal.

1893
Thomas Fripp, painter and future president of the British Columbia Society of Fine Arts (BCSFA), emigrates from Britain to B.C.

1895
Canadian branch of the Young Women's Christian Association (YWCA) is founded.

EMILY CARR AND HER TIMES

1899

In spring, Carr visits the Presbyterian mission school at Ucluelet, a Nuu-chah-nulth (Nootka) reserve on the west coast of Vancouver Island; the native people give her the name "Klee Wyck" (Laughing One); on the way home she meets William "Mayo" Paddon, who woos her unsuccessfully.

Carr leaves for England in August and enrolls in the Westminster School of Art in London; she is turned down when she offers her Ucluelet sketches to Beatrix Potter's publisher.

1901

Mayo Paddon visits and begs Carr to marry him; she sends him away.

Carr's toe is fractured and must be amputated, making it necessary for her to use a camp stool for the rest of her life when painting.

Hating London, Carr begins two years of instruction and sketching sessions in Hertfordshire, where she works with watercolourist John Whiteley, and in Berkshire and Cornwall, where she works with Julius Olsson and Algernon Talmage, with whom she first paints forest.

CANADA AND THE WORLD

1899

While studying painting in Paris, Sophie Pemberton is the first woman artist to win the *Prix Julian*.

Boer war begins in South Africa between the British and the Afrikaners; Canada sends troops; the war divides Canadians along French and English lines.

1900

In Canada, Mungo Martin carves his first totem pole, *Raven of the Sea*.

1901

Queen Victoria dies and is succeeded by her son, Edward VII.

EMILY CARR AND HER TIMES	CANADA AND THE WORLD
1903 Carr "cracks up"; her sister, Lizzie, takes her to the East Anglia Sanatorium, in Suffolk, where she is diagnosed with "hysteria."	**1903** French painter, Paul Gauguin, dies.
1904 Carr leaves the sanatorium and returns to Hertfordshire, depressed.	**1904** Pablo Picasso, Spanish painter, moves to France and begins his "Pink Period."
Carr leaves England; on her way home to Victoria she visits Toronto and the Cariboo, where clean air and open spaces improve her health.	
1905 Carr publishes a series of political cartoons in Victoria's *The Week*.	
1906 Carr moves to Vancouver; she rents a studio at 570 Granville Street, where she teaches art to children privately; her job teaching adult amateurs at the Vancouver Studio Club (VSC) and School of Art lasts only one month.	**1906** Amedeo Modigliani, Italian painter and scultor, moves to France.
Carr and Coast Salish basket maker, Sophie Frank, meet and become lifelong friends.	
1907 During a three-week cruise to Alaska with her sister, Alice, Carr first sees the totem poles of Alert Bay and Sitka; she decides to document what she sees as the vanishing heritage of B.C.'s native peoples.	**1907** Russian revolutionary Leon Trotsky escapes to western Europe and attempts to unify all the exiled social democratic factions opposing the Czar; he is seen often in Paris.

Emily Carr

EMILY CARR AND HER TIMES

Carr wins a prize at the VSC exhibition.

1908-1909
In summer, Carr travels to Alert Bay, Campbell River, Lillooet, Hope, and Yale, B.C.; she sketches at the Sechelt and North Vancouver reserves; in Vancouver she sketches in Stanley Park and teaches at Crofton House School for Girls.

1909
Carr is a founding member of the British Columbia Society of Fine Arts (BCSFA); she will exhibit with the BCSFA for most of her career.

BCSFA is incorporated; painter Thomas Fripp is the first president.

1910
Carr auctions some of her work to finance a trip; she sails for France with her sister, Alice; they settle in Paris in the district of Montparnasse.

Carr meets English painter Harry Gibb and his wife, Bridget; Gibb introduces Emily to modern French painting and suggests she work alongside "the stronger work of men"; Gibb exhibits Bonnard, Seurat, Manet, and Matisse.

Carr studies at the Académie Colarossi, but prefers private study with the Scot, Duncan Fergusson.

CANADA AND THE WORLD

1909
A.Y. Jackson returns to Canada from two years of study in Europe.

Jack Shadbolt, future Canadian painter and teacher, is born in England.

EMILY CARR AND HER TIMES	CANADA AND THE WORLD

Carr becomes ill; it seems that cities make her sick.

1911

Carr goes to Sweden to convalesce; she returns to France and follows the Gibbs to Crécy-en-Brie and St. Efflame; she goes to Concarneau for instruction in watercolour with New Zealand painter Frances Hodgkins; she has two paintings hung in Salon d'Automne exhibition in Paris, the same one that introduced the Cubists.

Carr returns to Victoria with a new, vigorous style of painting.

1912

Carr rents a studio at 1465 W. Broadway in Vancouver where she exhibits her French paintings; the critics are impressed, but the public is not.

In summer, Carr travels on Vancouver Island to Alert Bay and nearby Kwakwaka'wakw villages, on the mainland to the Upper Skeena River area, and to Haida Gwaii (Queen Charlotte Islands) where she makes friends with William and Clara Russ and, for the first time, sees D'Sonoqua.

1913

Carr rents Drummond Hall in Vancouver and exhibits nearly 200 Indian paintings, drawings, and sketches, which she is unsuccessful

1911

In Canada, painters Lawren Harris, J.E.H. Macdonald, and Tom Thomson become friends; Arthur Lismer emigrates from England and seeks work as a commercial illustrator in Toronto.

Wassily Kandinsky, Russian painter, co-founds the Munich-based *Blaue Reiter* group of artists.

1912

SS *Titanic* sinks.

1913

In Canada, A.Y. Jackson becomes friends with Tom Thomson; an Act of Parliament incorporates the National Gallery of Canada.

Emily Carr

EMILY CARR AND HER TIMES	CANADA AND THE WORLD

in selling to the provincial government.

Carr returns to Victoria; she builds Hill House on the family property at 646 Simcoe Street; the house has revenue suites.

1914-1926
Carr operates her apartment house and supplements her meagre income by raising English bobtail sheepdogs, making pottery, and hooking rugs; her reputation as an eccentric is enhanced by her choice of clothes and her unusual behavior; she has little time for painting.

1914
World War I begins when Britain declares war on Germany on August 4; Canada is automatically at war; young Canadians eagerly join the armed forces.

1916
Carr goes to San Francisco for eight months and is employed painting decorations for the St. Francis Hotel ballroom.

1916
In Canada, Arthur Lismer becomes principal of the Victoria School of Art and Design (later the Nova Scotia College of Art and Design); the WAAC moves its premises to 23 Prince Arthur Avenue, Toronto, Ontario; Myfanwy Pavelic, née Spencer, future Canadian painter, is born.

1917
In Canada, painter Tom Thomson mysteriously drowns.

Canadian War Memorial Fund sponsors over eighty artists to record Canada's participation in the war.

Trotsky helps Lenin organize the October (Bolshevik) Revolution in Russia.

EMILY CARR AND HER TIMES	CANADA AND THE WORLD
	1918 World War I ends; worldwide influenza epidemic kills 22 million people in two years.
1919 Edith Carr dies.	**1919** Theosophical Society of Canada is formed in Toronto.
	1920 In Canada, Franklin Carmichael, Lawren Harris, A.Y. Jackson, Franz Johnston, Arthur Lismer, J.E.H. MacDonald, and F.H. Varley, frustrated by the conservative and imitative quality of most Canadian art, form the Group of Seven; after their first exhibit at the Art Gallery of Toronto, they begin to identify themselves as a landscape school; they become closely associated with the Theosophical Society. William (Bill) Reid, future Northwest Coast artist, is born in Vancouver.
1922 Carr meets Carol Dennise Williams (later Pearson), a young woman who shares her love of "creatures" and painting; Carr ("Mom") and Williams ("Baboo") become lifelong friends.	
1923 Carr undergoes a difficult gall bladder operation; Lizzie nurses her for several months.	

EMILY CARR AND HER TIMES

1924 and 1925
Carr exhibits in Seattle with the group Artists of the Pacific Northwest; her contacts include painter Mark Tobey.

1926
Carr enrolls in a writing correspondence course with Hollywood's Palmer Institute of Authorship.

1927
Marius Barbeau and Dr. Charles F. Newcombe, provincial government ethnologist, have become important supporters of Carr; Barbeau and Eric Brown of the National Gallery visit her and select paintings for an exhibition in Ottawa.

Carr visits Frederick Varley in Vancouver, then travels by train to Toronto, Ottawa, and Montreal; she meets Lawren Harris and other Group of Seven members; their encouragement stimulates her art and helps her to achieve maturity in her painting.

1928
National Gallery buys three Carr watercolours; encouraged by the response to her painting in Ontario, Carr makes painting her priority and heads into the woods "singing."

CANADA AND THE WORLD

1925
Scottish landscape painter Charles Scott is the first principal of the Vancouver School of Decorative and Applied Arts; Frederick Varley is one of the teachers.

1926
Frederick Housser publishes *A Canadian Art Movement*, which celebrates the Group of Seven.

Carr begins a lifelong correspondence with Lawren Harris and a spiritual search that includes an investigation of theosophy.

In summer, Carr sketches at Alert Bay and Fort Rupert, in the Nass and Skeena River areas, and at Haida Gwaii.

Under the influence of Mark Tobey and Lawren Harris, Carr makes major changes in her painting style.

1929
Carr continues to participate in local and regional exhibits; her work is now included in major national exhibits in eastern Canada and the United States (U.S.).

Carr publishes "Modern and Indian Art" in the *Supplement to the McGill News*.

Carr visits Nootka and Friendly Cove in May and Port Renfrew in August; she observes that Indians have sold their best poles to museums; she paints *The Indian Church, Friendly Cove*.

Lawren Harris suggests that Carr stop working on Indian material and look to the forest for inspiration.

1930
Carr addresses the Women's Canadian Club of Victoria in conjunction with a solo exhibit at the Crystal Gardens.

1929
On Black Friday (October 28), the American stock exchange collapses; the ten-year-long Great Depression begins.

In the spring, Carr visits Toronto, Ottawa, and New York, where she meets painter Georgia O'Keeffe; she begins to receive wider recognition in eastern Canada and the U.S.

In August, Carr makes a final trip to First Nations sites on northern Vancouver Island; she meets the figure of D'Sonoqua for the last time.

Carr commences a pattern of spring and summer sketching expeditions around Victoria; she attends services and faith healings at the Victoria Unity Centre.

1931
Carr camps and sketches near Victoria with Edythe Hembroff at Cordova Bay in May, and at Goldstream Park in September, where she concentrates on the swing and sweep of large cedar trees.

Carr paints *Strangled by Growth* (D'Sonoqua); during the winter she works on portraits.

1932
Carr camps and sketches near Victoria with Hembroff at Braden Mountain in the Metchosin (Sooke) Hills in May; in June she camps alone in rented rooms in a farmhouse on Cedar Hill Road near Victoria's Mt. Douglas woods.

1931
Women Painters of Western Canada is founded; the Vancouver Art Gallery opens but ignores B.C. artists and almost all Canadian painters.

1932
In Canada, poet Dorothy Livesay is one of thirty-five people who organize the Progressive Arts Club to unite writers of the left in fighting for social change.

In Germany, the Nazis under their leader, Adolf Hitler, win a majority in the Reichstag elections.

CANADA AND THE WORLD

In December, hoping to establish the People's Gallery, Carr mounts an exhibit in her home; young artist Lee Nam is among the exhibitors; Jack Shadbolt chairs a meeting to discuss establishing a permanent gallery, but insufficient money is raised.

1933
Carr becomes a charter member of the Canadian Group of Painters.

In May and June, Carr takes a month-long sketching trip to the mountainous B.C. Interior; she purchases "the Elephant," a caravan trailer; in August and September, she camps and sketches at Goldstream Park.

In November, Carr visits the Chicago World's Fair and goes to Toronto where she again discusses theosophy with Lawren Harris and Bess and Fred Housser; as a result she decides to reject theosophy for her own religious practice.

1934
During May and June, Carr camps at Esquimalt Lagoon and the Strathdee farm on southern Vancouver Island; in the summer and fall she enrolls in writing courses.

In September, Carr camps again on Strathdee Farm.

1933
In Canada, the Group of Seven, having become as entrenched as the art establishment it has over-thrown, disbands and re-forms as the Canadian Group of Painters.

The gross national product of Canada has declined 42 per cent since the beginning of the Depression; 30 per cent of the work force is unemployed.

EMILY CARR AND HER TIMES	CANADA AND THE WORLD

1935
In June and September, Carr sketches at Albert Head in Metchosin.

Carr gives a "talk on art" at the Provincial Normal School; she befriends young Phyllis Hudson; she paints *Scorned as Timber, Beloved of the Sky*.

1936
Carr trades Hill House for a rental property and moves to 316 Beckley Avenue.

As persecution of Jews increases in Europe, Carr writes in her diary about "the war clouds hanging so low and heavy over everything."

In June and September, Carr camps at Spencer's sheep farm, Metchosin, on a site overlooking a gravel pit. These are her last trips in the Elephant.

Lizzie Carr dies of breast cancer.

1936
Tension builds in Europe as the Spanish Civil War begins and Italian dictator Benito Mussolini and German dictator Adolf Hitler proclaim the Rome-Berlin Axis; Nazis adopt the Nuremberg Laws, which divide the German people into Aryans and non-Aryans.

1937
A severe heart attack marks the beginning of the decline in Carr's health; writing replaces painting during her recuperation; while she is in hospital, Eric Newton, an English author and art critic, visits; he chooses paintings for exhibition and possible sale in eastern Canada.

Carr paints *Above the Gravel Pit*.

1937
Canadian writer Ethel Wilson publishes her first stories in British magazines; the Canadian Author's Association establishes the Governor General's Literary Awards.

Japan begins an aggressive war policy and invades China.

EMILY CARR AND HER TIMES	CANADA AND THE WORLD
1938	**1938**
Carr has her first solo exhibit at the Vancouver Art Gallery; an exhibit of several works at the Tate Gallery in London attracts critical attention.	Hitler marches into Austria; Britain appeases Germany at Munich.
1939	**1939**
Carr suffers a second heart attack in March; she spends several weeks in hospital; she begins to write in earnest "to forget being sick" and finishes her Indian stories.	World War II begins in September; Canada declares war on Germany.
Carr camps for three weeks in June in a rented cottage in Langford and in September in a one-room shack on Craigflower Road, Victoria; her heart condition forces her to work slowly.	
Carr's friend Sophie Frank dies.	
1940	**1940**
Ira Dilworth, Regional Director of the Canadian Broadcasting Corporation in Vancouver, arranges for radio readings of Carr's Indian stories.	In Canada, Bess Housser and Lawren Harris, having divorced their spouses and married each other, move to Vancouver.
Carr moves into her sister Alice's house.	English novelist Malcolm Lowry moves to B.C. and is claimed thereafter by the fledgling B.C. literary community.
In May, Carr camps for two weeks in a one-room shack at Metchosin near the gravel pit.	
A major stroke in June places Carr in hospital unable to speak; by August she is back at work on her stories.	

EMILY CARR AND HER TIMES

1941
Through the efforts of Dilworth and Harris, the Emily Carr Trust is founded; the Trust will give a permanent collection of her paintings to the Province of B.C. after her death.

The University Women's Club of Victoria sponsors a large celebration to honour Carr's seventieth birthday and the publication of *Klee Wyck*.

1942
Carr makes her final sketching trip in August; camps in a rented cabin at Mt. Douglas Park for "twelve days of gladness"; another stroke confines her to a bed in a nursing home where she begins to write again.

The Book of Small is published in the fall; it is named The Canadian Book of the Year.

Carr continues with writing (and some painting) despite being confined to hospital and nursing homes; she paints *Cedar*.

Carr wins the Governor General's Award for *Klee Wyck* and has a major exhibition at the Art Gallery of Toronto.

1943
Carr's paintings are received enthusiastically in four solo exhibitions in Montreal, Toronto, Vancouver, and Seattle.

CANADA AND THE WORLD

1941
B.C.'s first literary journal, *Contemporary Verse*, is founded; it will publish Dorothy Livesay and Earle Birney, among others.

In the Pacific, Japan bombs Pearl Harbor; the U.S., Britain, and Canada declare war on Japan.

1942
In Canada, Paul-Émile Borduas founds the Automatiste movement in Montreal; B.C.'s Earle Birney wins the Governor General's Award for poetry.

1943
In Canada, the Department of National Defence hires thirty Canadian artists to record the Canadian armed forces during World War II.

Carr is hospitalized with another stroke.

1944
Carr requires a wheelchair for her trips to the park.

Carr's work is shown for the first time in a commercial gallery; Dr. Max Stern of the Dominion Gallery, Montreal, arranges for a large exhibition and sale of sixty of her works.

Another stroke in September does not stop her from painting and writing.

The House of All Sorts is published in the fall.

1945
Carr names Dilworth, Harris, and Newcombe as trustees of her estate.

In February, while preparing for an exhibition at the Vancouver Art Gallery, Carr enters St. Mary's Priory for a rest; she dies there on March 2; she is buried in Ross Bay Cemetery, Victoria.

Various galleries buy major Carr paintings.

1946
Growing Pains is published.

1944
In Canada, B.C.'s Dorothy Livesay wins the Governor General's Award for poetry.

D-Day invasion of Europe on June 6 begins the liberation of Europe.

1945
World War II ends.

In Canada, Earle Birney wins the Governor General's Award for poetry a second time.

EMILY CARR AND HER TIMES	CANADA AND THE WORLD
	1947 Two Canadian writers publish their first novels: Ethel Wilson (*Hetty Dorval*) and Gabrielle Roy (*The Tin Flute*); Dorothy Livesay wins the Governor General's Award for poetry a second time; Malcolm Lowry's *Under the Volcano* is published.
	1948 In Canada, WAAC begins giving scholarships to artists, dancers, and musicians; Mungo Martin takes over the University of British Columbia totem pole restoration program.
	1951 In Canada, the Massey Commission recommends greater government encouragement and support for the arts; Bill Reid begins to investigate the art of the Haida, his mother's people.
	1952 Mungo Martin begins a replication program of old totem poles in Victoria.
1953 *Pause: A Sketchbook* and *The Heart of a Peacock* are published.	
	1959 Sophie Pemberton dies in Victoria, B.C.
1966 Carr's journals, *Hundreds and Thousands*, are published after Ira Dilworth's death.	

Sources Consulted

Books

BARTON, John. *West of Darkness: A Portrait of Emily Carr*. Kapuskasing, Ontario: Penumbra Press, 1987. Reprinted as *West of Darkness: Emily Carr: a self-portrait*. Vancouver: Beach Holme Publishing, 1999.

BLANCHARD, Paula. *The Life of Emily Carr*. Vancouver/Toronto: Douglas & McIntyre and Seattle: The University of Washington Press, 1987.

BRAID, Kate. *To This Cedar Fountain*. Vancouver: Polestar, 1995.

BRAID, Kate. *Inward to the Bones: Georgia O'Keeffe's Journey with Emily Carr*. Victoria: Polestar, 1998.

BRAID, Kate. *A Woman's Fingerprint: Georgia O'Keeffe Meets Emily Carr*. Salt Spring Island, B.C.: (m)Other Tongue Press, Limited Edition, 1997.

CARR, Emily. *The Emily Carr Omnibus*. Introduction by Doris Shadbolt, Vancouver/Toronto: Douglas & McIntyre and Seattle: University of Washington Press, 1993.

HALPIN, Marjorie M. (Foreword by Michael M. Ames). *Totem Poles: An Illustrated Guide*. Vancouver and London: University of British Columbia Press in

association with the U.B.C. Museum of Anthropology, 1981. Museum Note No.3.

LAWRENCE, Robin. *Beloved Land: The World of Emily Carr*. Vancouver/Toronto: Douglas & McIntyre and Seattle: University of Washington Press, 1996.

MASTAI, Judith. *Emily Carr*. Vancouver: Vancouver Art Gallery, 1991.

McNEIL, Florence. *Emily*. Toronto/Vancouver: Clarke, Irwin & Company, 1975.

NEWSLAND, Anne. *Emily Carr: An Introduction to Her Life and Art*. Willowdale, Ontario: Firefly Books, 1996.

PEARSON, Carol. *Emily Carr as I Knew Her*. Aurora: Prestige Printing, 1986.

SHADBOLT, Doris. *The Art of Emily Carr*. Vancouver/Toronto: Douglas & McIntyre, 1979.

SHADBOLT, Doris. *Emily Carr*. Vancouver/Toronto: Douglas & McIntyre, 1990.

TIPPETT, Maria. *Emily Carr: A Biography*. Toronto: Oxford University Press, 1979.

WALKER, Doreen, Ed. *Dear Nan: Letters of Emily Carr, Nan Cheney and Humphrey Toms*. Vancouver: University of British Columbia Press, 1990.

WEIER, John. *Twelve Poems for Emily Carr*. Winnipeg: Punchpenny Press, 1996.

WHITMAN, Walt. *Leaves of Grass*. New York: Quality Paperback Book Club, 1992.

Catalogues and Pamphlets

Emily Carr: Art & Process. Vancouver, Victoria, Kamloops: Ian Thom, Senior Curator, 1998-99.

Richard Carr House: A History. Research Section, Resource Management Division, Heritage Conservation Branch, Judith Stricker, Research Officer. Victoria: 1980.

To The Totem Forests: Emily Carr And Contemporaries Interpret Coastal Villages. Victoria: Jay Stewart and Peter Macnair, Curators, 1999.

Web Sites

www.aaf.gov.bc.ca (B.C. Ministry of Aboriginal Affairs)
www.bcarchives.gov.bc.ca (British Columbia Archives)
www.emilycarr.com (The Emily Carr House, Victoria, B.C.)

Index